Margaret Ross

basic skills

Rudolph Koch's Neuland lettering 2·3·91

ΞIABCD

Jenny
Kavarana

Dedication
To Suzanne, Andrew, Dominic and Matthew

The Lettering Workbook series comprises:

Volume 1 **Basic skills**	ISBN 0-289-80013-7
Volume 2 **Traditional penmanship**	ISBN 0-289-80015-3
Volume 3 **Applied lettering**	ISBN 0-289-80014-5
Volume 4 **Designing with letters**	ISBN 0-289-80016-1

LETTERING WORKBOOKS

basic skills

ANNE TRUDGILL

STUDIO
VISTA

Studio Vista
© Diagram Visual Information Ltd 1988

First published in Great Britain in 1989
by Studio Vista
an imprint of Cassell Publishers Limited
Artillery House, Artillery Row
London SW1P 1RT

British Library Cataloguing in Publication Data
Trudgill, Anne
 Basic skills. — (Lettering workbooks)
 1. Calligraphy
 I. Title II. Series
 745.6'1

ISBN 0–289–80013–7

The Diagram Group
Designer Philip Patenall
Editor Randal Gray
American consultant Marian Appellof
Art staff Linda Beresford, Louise Cousins,
 Robin Jennings, Lee Lawrence,
 Chris Logan, Paul McCauley,
 Geoff Mitchinson, Derek Powers,
 Debbie Skinner

Acknowledgements
We would like to thank the following
calligraphers for permission to produce
their work:
William Cartner (p47, *bottom*); Lindsay
Castell (p43, quotation from *The Idiot* by
Fedor M Dostoyevsky 1868/9); Barbara
Feld (p65, *top left*); Michael Herring (p64);
Margaret Kennedy (p65, *top right*); David
Mekelburg (p74, quoting from *Life in the
Snake pit* by Bette Howland); John Smith
(p75, *top*); Peter Thornton (p57, p63);
Wendy Westover (p75); John Weber
(p54); John Woodcock (p55, Quotations
from *The Family Reunion* by T. S. Eliot
1953, Victoria & Albert Museum MS Circ
169–1953 by permission of Faber & Faber
Publishers Ltd); the late Pamela Wrightson
(p71).

Printed and bound by Snoeck Ducaju & Sons,
Ghent, Belgium

Lettering Workbooks

THIS BOOK IS WRITTEN TO BE USED.
It is not meant to be simply read and enjoyed. Like a course in physical exercises, or any area of study, you must carry out the tasks to gain benefit from the instruction.

1 Read the book through once.
2 Begin again, reading two pages at a time and carry out the tasks set before you go on to the next two pages.
3 Review each chapter by re-examining your previous results and carrying out the review tasks.
4 Collect all your work and store it in a safe place, having written in pencil the date when you did the work.

LEARNING HOW TO DO THE TASKS IS NOT THE OBJECT OF THE BOOK. It is to learn lettering and calligraphy by practicing the tasks. Do not rush them.

LETTERING WORKBOOKS ARE:
1 A program of clear instruction.
2 A practical account of various techniques and procedures.

Like a language course, the success of your efforts depends upon you.
YOU DO THE WORK!

Contents

fghijklmnopqrs

fghijklmnopqrs

THANK you

Topic finder

Introduction

Calligraphy is an art which comes through practice and patience, so in this book, practice is fun and informative, rather than dreary and monotonous. Confidence which gives lettering a rhythm and a sense of freedom cannot come without understanding the basic structure of letters. Your calligraphy will develop as you learn the basic structure, the various techniques and experiment with different lettering styles.

Calligraphy is not a matter of copying but rather a question of developing a skill and using it appropriately to express the meaning of a text. As you work your way slowly through this book you will learn to achieve small successes step-by-step.

It is important to familiarize yourself with the pens and drawing instruments. This process involves playing with them. Just as children learn naturally through play, so will you! Mastering your tools will give you a basic confidence which will gradually develop as your skills improve.

It is important to allow plenty of time to enjoy your work. Go slowly and you will gain the maximum benefit from what you are learning. Instant results are not really satisfying, so if time is short, you simply have to expect less of yourself to begin with. There are no short cuts to practicing a craft.

" *The art of calligraphy is a form of recreation in which one unburdens one's heart and soul, dissipates care and gets rid of melancholy.* **"**
T'SAI YUNG

Chapter 1

> *The lyf so short, the craft so long to lerne.*
> CHAUCER

Workstation

Consider creating a calligraphy workstation in your home. You will need:

A A source of natural light and a desk lamp.

B A steady, strong, flat table on which to put the drawing board.

C A drawing board (preferably adjustable).

D A comfortable adjustable chair.

E Space to keep tools and equipment within easy reach.

F Jars or cutlery tray to store pens and brushes without damaging them.

G Space to store work. (You may like to keep work in a portfolio or put it under the bed between sheets of card.)

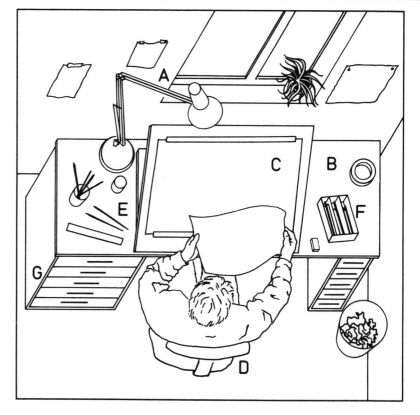

BASIC TOOLS

Calligraphy is the craft of writing beautifully. It will take much time and patience before you acquire the range of skills which are the hallmark of a good calligrapher.

To begin with, you will need a collection of tools. These should be kept clean and ready to use, so that whenever you find that you have some time available, you can start practicing your letters straight away. Cleaning pens and brushes immediately after use is also a good habit.

In this chapter you are introduced to various tools and writing instruments, which, as a beginner, you are recommended to use. You will be advised on how to care for them, and the illustrations of the various pen marks show you the effects which can be obtained from each nib or pen.

Your hand and your eye are two other important tools! With practice, they will learn to work together and you should be able to achieve better results than you might now think possible.

This book aims to show you how much fun practicing calligraphy can be. The tasks in this chapter are designed to help you establish some good habits related to your calligraphy equipment. You should keep your tools safely, and not allow others to use them. Soon your calligraphy tools will be a source of new enjoyment and must not become an excuse for bad workmanship!

Task

Prepare a drawing board

1 If you do not have a drawing board, you can make one. Find a strong, flat board with straight edges. Prop it up at an angle of 45° using bricks or books. Make sure it is firm.

2 Tape three sheets of good thick paper securely to the board to create a firm but "sympathetic" writing surface.

3 Use a sheet of ruled lines as a guide underneath the sheet of paper you're writing on.

4 Write onto a sheet of layout paper which is not taped down. This paper needs to be free to move upward as you write down the page so that your hand stays at the same level on the board at all times.

5 Use a sheet of layout paper to protect your work from grease and splatters etc.

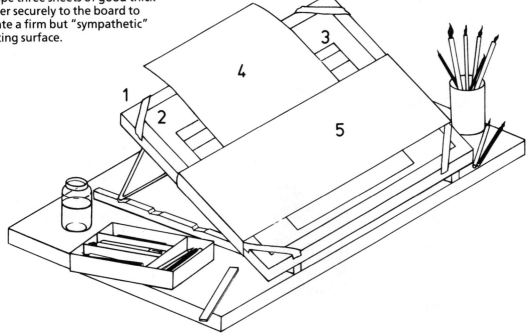

Pens and writing tools

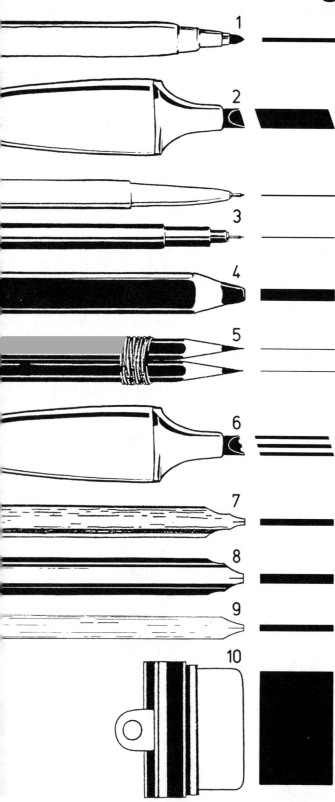

These two pages illustrate the variety of writing implements available. The ones marked with an asterisk (*) are the ones you need to start with. Left handed readers should refer to page 15 and to the end of the chapter before attempting tasks.

1 Instant marker pen.
2 Chisel-ended felt tip pen *.
1 and 2 are ideal for practicing and planning layouts. They are available in a variety of widths and colors.
3 A fine tip pen is useful for ruling-up templates (see page 40).
4 A carpenter's pencil for practice and experimenting with different layouts.
5 The double pencil is the most useful dry pen of all. Simply bind two pencils together at the top and bottom with tape or rubber bands to produce an outline pen which shows clearly the letter construction. To make a broader pen, place an eraser between the two pencils and then bind them together. If you want a narrower pen, shave off some of the wood from the pencils along their length before binding *.
6 Chisel-ended felt tip pen which has had small wedges cut out of the tip with a scalpel, producing a decorative mark.
7 Reed pen. These can be made from bamboo, honeysuckle and other tubular stems. The reed pen is the original broad-nibbed pen and is ideal for large letters.
8 Synthetic "reed pen". Nylon tubing from hardware stores can be made into one. The nib can be cut into to make a pen which produces a double line.
9 A quill. This is made from a cured flight feather of a goose or swan which has been shaped at the end with a sharp knife.
Pens 7, 8, and 9 can be used with added reservoirs (see page 15).
10 Homemade poster pen. Made by covering a piece of balsa wood with felt and gripping them together in a bulldog clip. This produces an inexpensive pen with a broad nib, which is useful for display work, experimenting or for children to practice with.

Task
Collecting pens
Start collecting and making pens. Store the pens with the nib pointing upwards, not flat in a box. A jar is ideal for this. Having several pen holders will avoid the need to change nibs too often — this can damage them.

11 William Mitchell Roundhand nib with a slip-on reservoir (top, bottom and side views).

12 Brause nib with its reservoir on top of the nib. Both 11 and 12 are available in a range of widths (see page 15).

* You will need either 11 or 12.

13 Poster pens also have their reservoirs on top of the nib and a right oblique writing edge. This pen is ideal for decorated letters and display work.

14 The Witch pen has a writing edge which copes with textured papers very well.

15 Boxall Automatic pen. This range includes a variety of nib widths.

16 Boxall Automatic pen with a decorative nib.

17 Scroll nibs are available in sets consisting of a variety of widths, all giving a double line.

18 The Decro Script pen is useful for practicing skeleton letters in various sizes.

19 Coit pens are expensive but have a variety of writing edges which produce decorative marks, and are ideal for display work.

20 Fountain pen. Using a fountain pen with an italic nib for your everyday writing will help to improve it*.

21 A shadow fountain pen nib gives two lines. This is ideal for analysing your strokes as well as being decorative.

Task
Preparing nibs
New nibs need to be cleaned before use, otherwise the ink will not flow freely. Remove the manufacturer's lacquer from both nibs and reservoirs, either by boiling them in water or by putting them into the flame of a lighted match and then wiping clean.

Task
Making mountains
Rule writing lines 1¼in (30mm) apart on 11 × 14in (A3) paper. With the double pencil pen (no.5) make mountains with a 45° angle. Keep the angle constant. This simple practice exercise is helpful to the beginner even before you start writing.

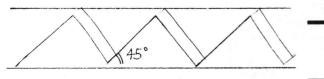

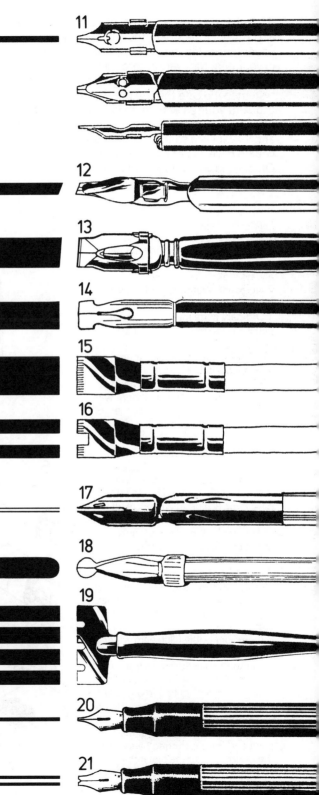

Additional materials

As well as selecting a writing implement you must also consider the size of the nib, the right type of paper to use and the ink or paint that you will put in your pen. Nibs vary according to manufacturer and each manufacturer uses a different numbering system to indicate the size of the nib. Try to acquaint yourself with these before choosing a nib.

It is a good idea to keep pens and pots of paint and ink labelled so that you know exactly what you do have. Paper can be kept in piles or folders. Organizing your equipment and materials in this way saves time and prevents mistakes.

Inks

Experiment with different combinations of ink, paper and writing board angle to find out what suits you best. When choosing ink always make sure it is non-waterproof. Waterproof inks contain gum which will clog your pen.

1 Ordinary permanent black fountain pen ink is the best ink to start off with.

2 Black Indian ink is good for finished work as it is dense and very black.

3, 4 and **5** There are many other types of ink on the market. Experiment with different colors. Secure ink bottles to the table to avoid spillage.

Paint

6 Gouache. A few basic gouache paints (designer colors) will give a new dimension to your work. The following colors would be useful to have: zinc (Chinese) white, cobalt blue, lemon yellow, emerald oxide of chromium (mix in lemon yellow to give it body), spectrum red or vermilion hue.

7 A mixing dish for preparing paint. If you already have watercolors you can use them and add zinc white to give opacity to your letters when it is appropriate.

8 A dropper bottle filled with water is ideal for mixing paint. Always add the water to the paint drop by drop. If you are using paint for a long piece of work, you will need to add drops of water occasionally to compensate for evaporation.

9 Use old, cheap brushes for mixing paint and for transferring paint from the mixing dish to the nib. If the brushes have long handles, shorten them to prevent accidents.

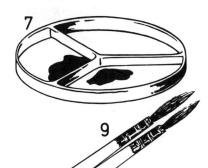

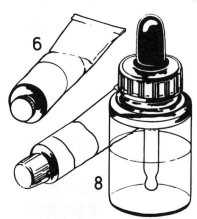

Task

Paper storage

If you don't already have a plan chest or set of shallow drawers you can make a paper storage system without glue or nails. You need some large flat sheets of wood and some thin strips of wood 1-2in (2.5-5cm) thick. Place one of the flat sheets on a stable surface, put a strip of wood down either edge and place another flat sheet on top. This creates a compartment which paper can be slid into. Continue building upwards until you have enough space for all your paper.

Task

Tool storage

Protect your rulers, pencils, set squares and cutting knives by storing them in a cutlery tray or shallow box. Larger tools (T-squares, etc) can be hung from nails or hooks in the wall. Check your equipment with the list on page 16.

Nib widths

Nibs are available in an enormous range of widths. The wider the nib, the greater the contrast between the thick and thin strokes produced. Two manufacturers nib sizes are shown here.

Left handed calligraphers

If you are left-handed you may find left oblique nibs (A) easier to use than square cut ones (B). You have to decide what is best for you. Several first class calligraphers are left handed so it is no excuse for not succeeding!

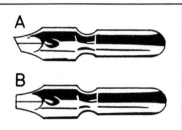

William Mitchell roundhand nibs **Brause** nibs

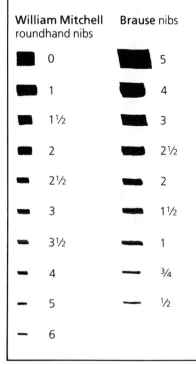

William Mitchell	Brause
0	5
1	4
1½	3
2	2½
2½	2
3	1½
3½	1
4	¾
5	½
6	

Reservoirs

Reservoirs hold ink on the nib and help to control the ink flow. There are five basic types:

a This reservoir slips underneath the nib and forms a shallow cup shape which just touches the slit. It should not force the slit open. This type is easily removed for cleaning.

b Similar to (a) but sits on top of the nib and can also be removed for cleaning.

c The shape of this nib creates its own reservoir. Work with the hairlines on the writing edge facing upwards as these help control ink flow. Clean the nib by passing a soft cloth between the two "blades".

d Coit pen reservoir. These occasionally need to be taken apart to be cleaned.

e (Cross section) This reservoir is made from a piece of aluminum from a soft drink can. Cut the metal into small strips, bend into an S shape and tuck into the barrel of your reed or nylon pen (such as pens 7 and 8 on page 12).

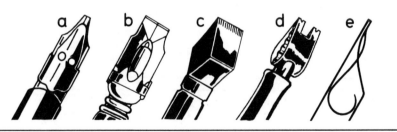

Paper

You will probably use a great deal of paper so you will need to locate a good art shop or a specialist paper supplier so that you can stock up from time to time. Good paper is worth paying extra for, but only buy small quantities until you find which ones you like. You need to consider three main factors when choosing paper: weight (thickness), surface texture ("tooth"), and finish (absorbency). If you buy some new papers, write the name and other details in a corner so that you can easily reorder it if you find you like using it. Experiment with different paper, ink and pen combinations. To begin with, buy an A3 layout pad. This is an inexpensive, translucent, lightweight paper which you can use for practice and pasting up. Guidelines placed underneath will show through. Some good quality drawing paper is very useful so try a few different weights, then stock up with ones you like. Parch marque is a substitute for parchment and is ideal for making a finished piece look interesting. Fabriano paper, made from cotton, comes in several weights and is very good to use.

Size	DIMENSIONS METRIC	IMPERIAL	NEAREST US EQUIVALENTS
A5	148 × 210 mm	5¾ × 8¼in	5½ × 8½in
A4	210 × 297mm	8¼ × 11¾in	8½ × 11in; 9 × 12in
A3	297 × 420mm	11¾ × 16½in	11 × 14in; 14 × 17in; 11 × 17in; 12 × 18in
A2	420 × 594mm	16½ × 23½in	18 × 24in; 19 × 24in

Review

This first chapter has shown you the essential tools for calligraphy. You now know how to store, prepare and clean them, so once you have completed the tasks and the checklist, you should be quite ready for Chapter 2 where you learn the letterforms.

Posture

Body weight should go through the spine. Legs and both feet should rest squarely on the floor. Avoid weight going forward into the arms.
This position should give you:
- Steady ink flow
- Good view of your work
- Relaxed working posture which will not tire you

Hints for left handed calligraphers
- Left oblique nibs can be purchased. If required, the angle of the nib can be increased by rubbing with FINE silicon carbide paper.
- Tilt the paper or steepen the angle of the drawing board to make yourself more comfortable.
- Keep work to the left hand side of your board. Turn your head a little to the left and don't write across your body – only as far as your chin. Keep your elbow tucked into your waist.

Task
Sketch book
Buy a small sketch book and keep it on your person, along with a felt pen or fountain pen. Using this you can doodle and design whenever an idea occurs.

Task
Quotations notebook
Buy a small notebook in which you can jot down quotations and poems which you may one day like to write out.

Basic equipment checklist
Some of these may be things you already have. Items marked with an asterisk (*) are not essential right at the beginning, but would be very useful as you progress through the book.

1 Chisel edged felt tip pens in various sizes, ¼-⅕ in (3-5mm)*
2 Two 2B pencils bound together top and bottom
3 Several round pen holders
4 Set of nibs for the pen holders – either Brause or William Mitchell
5 Several slip-on reservoirs if you use William Mitchell Roundhand nibs
6 No. 3 or 3A Automatic pen*
7 No. 7 Automatic pen*
8 Fountain pen with italic nib. Usually packed with three nibs and some ink cartridges
9 11 × 14in (A3) layout paper pad
10 Two 18 × 24in (A2) sheets of paper
11 Hot-pressed (smooth) paper from art shop to experiment with
12 Bottle of fountain pen ink
13 Bottle of black Indian ink (non-waterproof)
14 4 Designer's Gouache colors*
15 4 cheap brushes for mixing paint*
16 Dropper bottle containing distilled water
17 Blu Tak, plasticine or similar for securing bottles to the table
18 Palette or screw-top jars and water jar
19 Soft cloth
20 Masking tape
21 Typewriter correction fluid*
22 Eraser
23 Ruler
24 Craft (X-Acto) knife
25 Triangles (set squares) 30°/60°, 45°
26 Pencils – HB and softer for writing; 3H (or harder) for ruling lines
27 Pencil sharpener or old craft knife
28 Compass for circles and arcs*
29 Dividers for accurate measuring*
30 T-square for ruling parallel lines quickly and accurately*
31 A drawing board, of a minimum 16×20 in (400×500mm)
32 Comfortable chair/stool and table
33 Well-lit work area
34 Spotlamp
35 Storage facilities

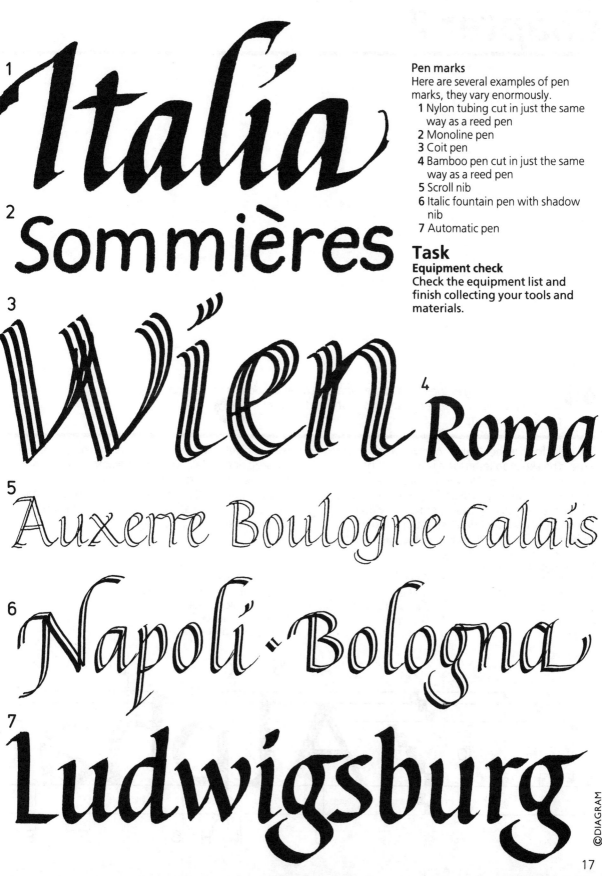

1 *Italia*

2 Sommières

3 Wïen

4 Roma

5 Auxerre Boulogne Calais

6 Napoli · Bologna

7 Ludwigsburg

Pen marks

Here are several examples of pen marks, they vary enormously.

1 Nylon tubing cut in just the same way as a reed pen
2 Monoline pen
3 Coit pen
4 Bamboo pen cut in just the same way as a reed pen
5 Scroll nib
6 Italic fountain pen with shadow nib
7 Automatic pen

Task

Equipment check
Check the equipment list and finish collecting your tools and materials.

©DIAGRAM

Chapter 2

The letterform is the "hand" or style in which you write. The skeleton letterform is the most basic form of the upper and lower case alphabets (majuscules and minuscules). The skeleton letters can be made with any implement as they do not rely on the "thick and thin" effect of a broad-nibbed pen. For this reason no pen angle or ladder

(see *opposite*) is needed. You can make the letters as large or as small, thick or thin as you wish. The other two letterforms in this chapter, Foundational and Italic, require you to use a broad-nibbed pen. Familiarizing yourself with the points shown here will help you start using the pen.

Terms used in lettering

A Serif
B Stem
C Ascender
D Arch
E Hairline

F Bowl
G Counter
H Foot serif
I Descender
J Cross-bar

K Writing line
L x-height (height of minuscules)
M Majuscule (capital) height
N Height of ascenders
O Depth of descenders

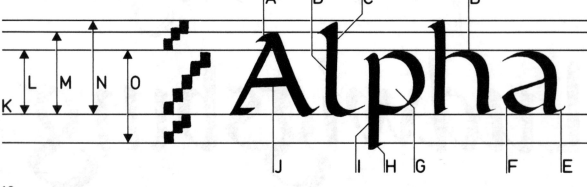

18

LETTERFORMS

In this chapter you are shown a skeleton alphabet to teach you the proportions of the letters. This will give you a knowledge of the basic Roman alphabet.

The next step is to take up the broad-nibbed pen and, after some initial pen exercises, learn the shapes and stroke order of Edward Johnston's Foundational hand. The minuscule hand is based on an old manuscript called the Ramsay Psalter which Johnston studied in the British Library in London.

Roman-based majuscules are shown next. These, together with Foundational minuscules, form the best-known version of the letters of the alphabet.

Formal Italic and the less formal Italic handwriting are shown at the end of the chapter. Instructions are also given for flourishing Italic and some alternative forms are included.

Once you are familiar with these three basic styles you will be ready to begin a few simple writing projects.

Ladders

The height of each style of letterform is set at a specific number of nib widths. Therefore the nib you use acts as a measuring unit to find the height of the letters. The nib widths are made with a pen angle of 90° and are piled up in a formation known as a ladder. You must make a new ladder each time you use a different size of nib or change lettering style. In this way, whichever size nib you use, your letters will always be in the correct proportions. For example, Foundational majuscules (**A**) are 6 nib widths high and the minuscules are 4½ nib widths. Italic majuscules (**B**) use 7 nib widths and the Italic minuscules are 5.

Guidelines

Guidelines are lines which act as a guide for the proportions of the letterforms. These proportions are found by making a ladder and then ruling pencil lines from it. They can either be fine pencil lines ruled on the writing sheet itself or templates placed under the writing sheet so that the lines show through.

Pen angles

The pen angle is the angle between the flat edge of the nib and the horizontal writing line. This varies depending on which letterform you are writing.

90° for ladders

30° for Foundational hand

45° for Italic

Skeleton letters

The alphabet we know today has two basic forms – capitals or upper case letters (majuscules) and lower case letters (minuscules). The terms upper and lower case originated in the typesetting industry. The majuscule type was kept in a separate flat wooden tray (case) above the minuscule tray. The skeleton alphabet (shown *right*) is the first lettering style to learn. It is the most basic form of the alphabet and has no thick or thin strokes. For this reason it can be made with any monoline pen (any pen with a Round nib) and needs no ladder or pen angle. The x-height of the minuscules should be half the height of the upper case, while the ascenders of the minuscules should equal the height of the upper case letters. When learning the majuscules it is useful to divide them into four groups based on their proportional spaces. Familiarizing yourself with this alphabet and memorizing the stroke order will give you a firm grounding in the art of lettering.

1

2

3

4

Proportional groups
1 C D G O Q are based on a circle. D and G use the edge of the rectangle.
2 A H N T U V X Y Z all fit into a rectangle. Note that the crossbars on A and H are at different heights.
3 B E F J K L P R S use half a square. Curves in the lower section need to be a fraction larger to stop letters looking top-heavy.
4 M fits into a square and W (double V, not double U!) is the widest letter. I is the narrowest.

Task
Letter groups
Familiarize yourself with the letter groups. Rule guidelines ½in (13mm) apart on some layout paper and, using a 2B pencil, work through the majuscule alphabet.

Task
Decro Script pen
Using a script pen (No 18 on page 13) or a round-tipped felt pen, go through the groups of majuscules again with lines ¾in (20mm) apart.

Task
Proportion
Write out the whole alphabet using whichever tool you prefer. See if you can keep the proportion for each letter correct even though you are now mixing up the letter groups.

Letter spacing
The skeleton alphabet is ideal for practising letter spacing as its simplicity allows faults to become obvious.

The most important thing to remember is to take the shape of the adjoining letters into account. Hints for well-balanced lettering:
● Leave a large gap between the two verticals (**1**).
● Put one vertical and one round letter closer together (**2**).
● Put two round letters even closer together (**3**).
To put it simply, regular spacing, that is, leaving the same size gap between each letter, is INCORRECT (**4**). Follow the above three hints and make your spacing irregular (**5**). Balance the AREAS, not the distance, between letters.

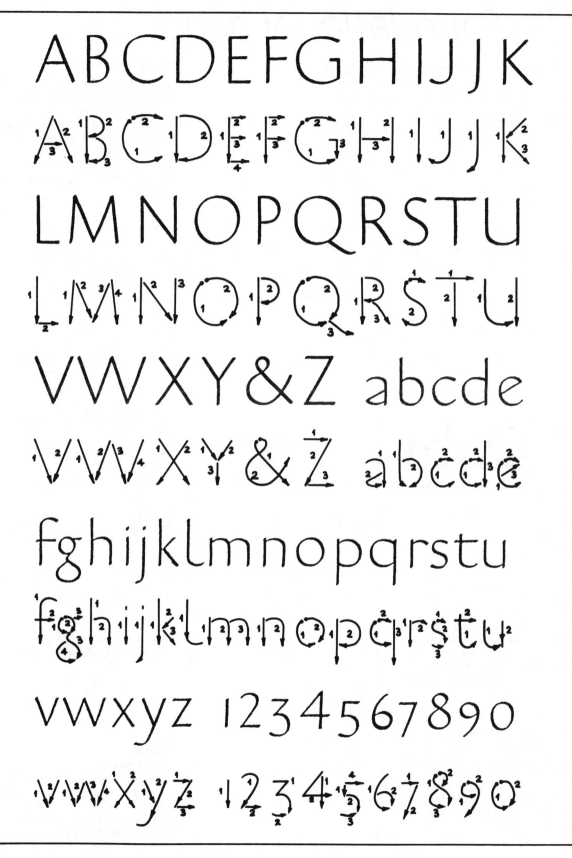

ABCDEFGHIJJK

LMNOPQRSTU

VWXY&Z abcde

fghijklmnopqrstu

vwxyz 1234567890

The Foundational hand

The Foundational hand is the name given by the calligrapher and typographer Edward Johnston to the style he developed in the early years of this century. It is based on his study of the Ramsay Psalter, a 10th century Carolingian manuscript in the British Museum (see detail on page 36.) This minuscule alphabet is used with majuscules based on the classic Roman capitals. They keep the same proportions and quality of balance that the stonecut letters have.

Task
Pencil mountains
Using two 2B pencils secured together at the top and the bottom, practice holding the pen at a 30° writing angle and make several rows of mountains. Check the angle as you finish each line. Then speed up a little and enjoy the rhythm.

Foundational
The hand has an x-height of 4½ nib widths, with an ascender height of 7 nib widths, and a capital height of 6 nib widths. The basic shape is the round O and the letters stand vertically without a slope. The hand is written with the pen at 30° to the writing line, except in the case of some of the capital letters when several changes in pen angle must be made (see following pages).

Task
Ladder
Make a ladder upwards from your writing line to find out how high 4½ nib widths is using double pencils. When you have that height draw another line so that you have two lines to guide you. Practice the O shape using two pulling strokes all the time, first anticlockwise, then clockwise. You start at 11 o'clock and travel round to 5 o' clock each time.

Task
Foundational minuscules
Work through the minuscule alphabet taking care to keep your letters 4½ nib widths high. Maintain the height, but steepen the angle when you get to the letters v, w and z. Date these practice sheets.

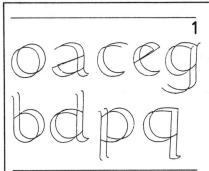

1

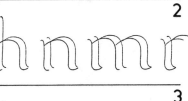

2

3

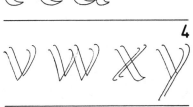

4

5

Minuscule letter groups
Don't write out the alphabet. Look first at the groups of letters. They are grouped according to their shape and it is easier to stick to one basic shape at a time.

Group 1 The O shape
Work around from 11 o'clock to 5 o'clock, first anticlockwise, then clockwise. Follow the stroke order from the alphabet diagram.

Group 2 The arch shape
Note how it relates to the O and is not angular at all.

Group 3 The inverted arch, the u shape
l and t both have stable bases to sit on.

Group 4 Diagonals
The angle is steepened for these strokes, otherwise they would spread too wide.

Group 5 The remaining letters
The shapes of these letters have little in common, but all need individual attention during construction.

The construction of the serif is illustrated for you on page 24.

Task
Letter groups
Still using the double pencil pen work your way through the five groups of letters. Write each group three times before you move on to the next.

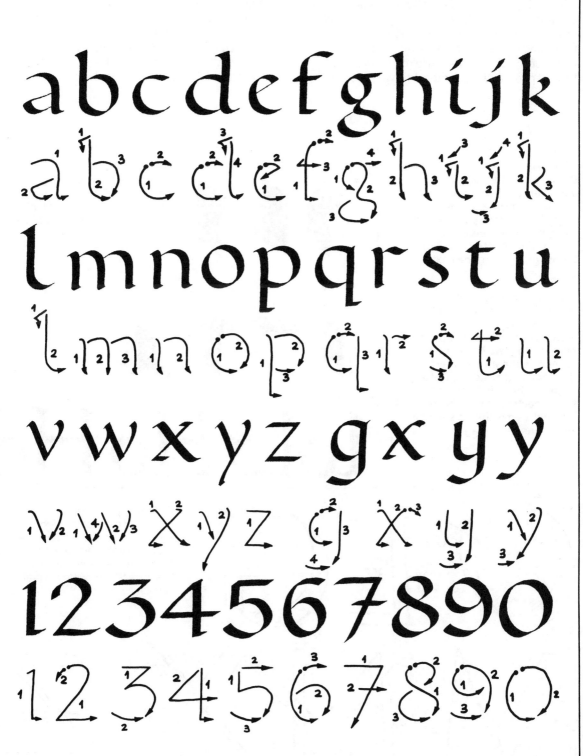

Foundational majuscules

The Foundational hand majuscule alphabet is a modern version of the classic Roman capitals alphabet which has been adapted for use by the broad-nibbed pen. The original Roman capitals, for example those seen on Trajan's Column in Rome (see page 36), have inspired lettercutters, typographers and signwriters for two thousand years. They were originally drawn with a brush before being cut with a chisel.

They aimed to convey the power of the Roman Empire. The elegance of these letters has been captured in the modern pen version which, when used with the minuscules, makes one of the most popular hands used by calligraphers.

Task
Stroke order
Before going through the alphabet turn back to page 20 and, using these letter groups, begin learning the stroke order using the double pencil pen. Write each group of letters three times before going on to the next.

Task
Capitals stroke by stroke
When you feel ready, start to work your way through the alphabet using a double-pencil pen, making two copies of each letter. Use the stroke order diagrams and make each letter 7 nib widths high. Date these sheets when you have finished. Remember to steepen stroke angles on diagonals.

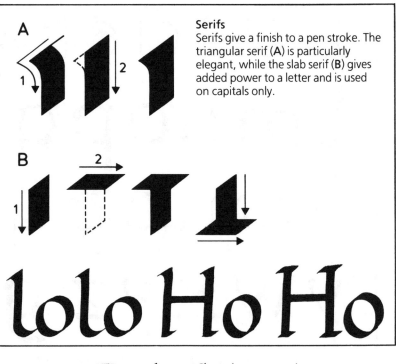

Serifs
Serifs give a finish to a pen stroke. The triangular serif (**A**) is particularly elegant, while the slab serif (**B**) gives added power to a letter and is used on capitals only.

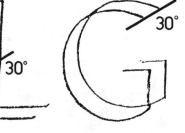

Changing pen angle
The pen angle used is 30°, but there are a few exceptions to this. The diagonal strokes are steepened to 45° and occasionally the pen is flattened to a mere 5° in order to maintain a harmonious look.

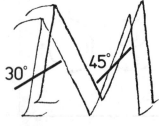

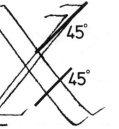

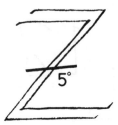

ABCDEFG

A B C D E F G

HIJKLMN

H I J K L M N

OPQRSTU

O P Q R S T U

VWXY&Z

V W X Y & Z

Practicing Foundational

The nature of practice is that while it is very necessary, it can be boring! Here are some ideas for you to work on and develop while you practice the Foundational hand and Roman capitals. Do not be tempted to rush on and try the Italic at this stage. There are several differences between these two hands that may confuse you. Before you leave the Foundational hand why not write out a small quotation.

For advice on layout turn to pages 46-47.

c e m x
s ss sss lll x
eeee &&¾ ss
ff mí
? " mí
mín ohio '

ABLE · BAT · CAT · DOG ·
I suggest experimenting with
EGG · FISH · GET · HIGH ·
capitals, serifs & lower case using
ICE · JOE · KATE · LION ·
different nib sizes, remembering
MAN · NUT · ORBIT ·
that nib widths are the measur-
PIP · QUILL · RAT · STY ·
ing unit for letter height & you
TOP · UNITY · VIEWS ·
aim for roundness and check for
WOW · X-RAY · YOUNG
even spacing by reversing the page
& ZEST · EXERCISES!

Doodling
Above, doodling does not need concentration and can be very relaxing. Try to keep your pen at the correct angle.

Task
Words
Go through the alphabet using a short word for each letter (*left*). Continue even if some words look very bad. The aim is to keep writing and fill a sheet or two with words.

Task
Naming names
Repeat the previous task using people's names instead of words. Work right through the alphabet. Date it and keep for reference.

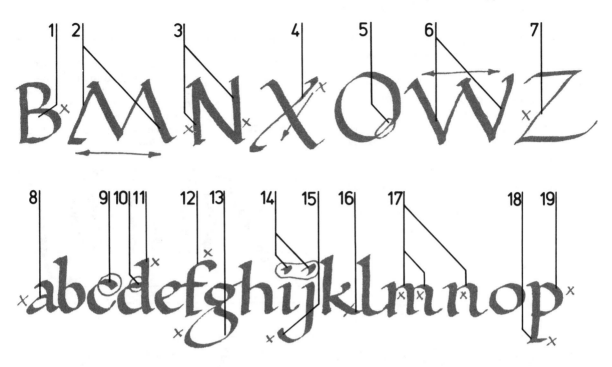

Problems

A student's early attempts at the alphabet are shown here to demonstrate some of the problems you might be experiencing. With capitals or majuscules keep the lines straight or circular. Don't invent swoops and curves. Don't go too low before you arrive at the halfway mark on the letters P R F E K B. Check the proportions by turning the page upside down, constructional mistakes are easily revealed with this simple procedure. Try not to be over critical.

1 Bottom bowl too wide.
2 Feet are splayed out too wide, so alter angle to 45°; remember the square.
3 Side strokes too thick, need to change pen to 45° angle.
4 Lost control! 45° angle needed.
5 This lacks confidence, a good attempt.
6 Too wide, 45° angle needed. Blots and smudges are a beginner's hazard. Stroke 4 pushed up instead of pulled down.

7 A weak middle stroke, flatten the pen angle here.
8 Wrong proportions.
9 Too curved.
10 Bad join between two strokes.
11 Clumsy serifs.
12 Too hooked.
13 Control lost.
14 Dot too comma-like.
15 Hook far too big.
16 Leg stroke too long.
17 Wobbly arches.
18 Too heavy.
19 Poor curve.

Pen play

It's essential to feel at ease when you are learning calligraphy. As well as practicing the stroke order, try some drawing with the pen. Some simple patterns based on letterforms are shown here.

©DIAGRAM

27

The Italic hand

The Italic hand was developed in Italy during the Renaissance. There were famous writing masters then as well as many artists and craftsmen, and we still refer to their teaching examples today. There are several different versions of Italic: formal, informal, pointed, cursive and chancery.

Additionally, it can be compressed, extended, flourished and decorated. It is the most flexible of all the calligraphic hands.

All Italic hands share two basic characteristics, the branching arches and the elliptical stress, which make it faster to write than round hand. Don't try to speed up when you write, think instead of the shapes and the rhythm; speed will come later.

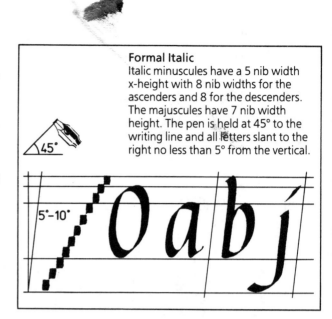

Formal Italic
Italic minuscules have a 5 nib width x-height with 8 nib widths for the ascenders and 8 for the descenders. The majuscules have 7 nib width height. The pen is held at 45° to the writing line and all letters slant to the right no less than 5° from the vertical.

Pen play
The simple pen exercises (*left*) will give you a "feel" for the Italic hand.

Changing proportions
The Italic hand lends itself to decoration. Descenders and ascenders can be extended and flourished. When you are more confident you can try this by changing the proportions when ruling up and allowing extra space above and below the x-height.

If you are writing out a poem, or anything with more than three or four lines, keep your ascenders and descenders controlled as they can interrupt the flow of the whole piece if they are too long. On the other hand, elegance and charm can be added to Italic by increasing the ascenders and descenders. You will soon learn when that would be appropriate.

Task
Italic minuscules
Practice the pen play exercises first before working through the minuscule alphabet. Use your double pencil pen the first time and concentrate on the 45° pen angle. Try to maintain it happily throughout an 11 × 14in (A3) sheet of mark-making exercises.

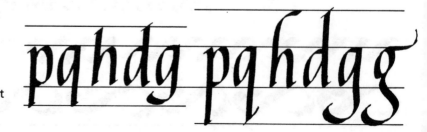

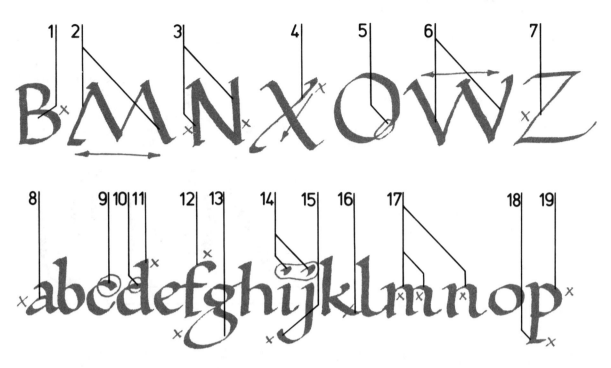

Problems

A student's early attempts at the alphabet are shown here to demonstrate some of the problems you might be experiencing. With capitals or majuscules keep the lines straight or circular. Don't invent swoops and curves. Don't go too low before you arrive at the halfway mark on the letters P R F E K B. Check the proportions by turning the page upside down, constructional mistakes are easily revealed with this simple procedure. Try not to be over critical.

1 Bottom bowl too wide.
2 Feet are splayed out too wide, so alter angle to 45°; remember the square.
3 Side strokes too thick, need to change pen to 45° angle.
4 Lost control! 45° angle needed.
5 This lacks confidence, a good attempt.
6 Too wide, 45° angle needed. Blots and smudges are a beginner's hazard. Stroke 4 pushed up instead of pulled down.

7 A weak middle stroke, flatten the pen angle here.
8 Wrong proportions.
9 Too curved.
10 Bad join between two strokes.
11 Clumsy serifs.
12 Too hooked.
13 Control lost.
14 Dot too comma-like.
15 Hook far too big.
16 Leg stroke too long.
17 Wobbly arches.
18 Too heavy.
19 Poor curve.

Pen play

It's essential to feel at ease when you are learning calligraphy. As well as practicing the stroke order, try some drawing with the pen. Some simple patterns based on letterforms are shown here.

©DIAGRAM

27

The Italic hand

The Italic hand was developed in Italy during the Renaissance. There were famous writing masters then as well as many artists and craftsmen, and we still refer to their teaching examples today. There are several different versions of Italic: formal, informal, pointed, cursive and chancery.

Additionally, it can be compressed, extended, flourished and decorated. It is the most flexible of all the calligraphic hands.

All Italic hands share two basic characteristics, the branching arches and the elliptical stress, which make it faster to write than round hand. Don't try to speed up when you write, think instead of the shapes and the rhythm; speed will come later.

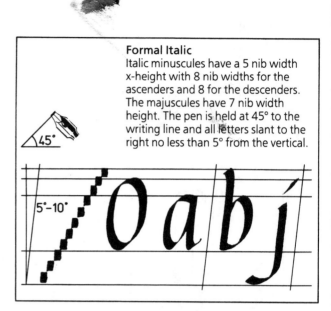

Formal Italic
Italic minuscules have a 5 nib width x-height with 8 nib widths for the ascenders and 8 for the descenders. The majuscules have 7 nib width height. The pen is held at 45° to the writing line and all letters slant to the right no less than 5° from the vertical.

Pen play
The simple pen exercises (*left*) will give you a "feel" for the Italic hand.

Changing proportions
The Italic hand lends itself to decoration. Descenders and ascenders can be extended and flourished. When you are more confident you can try this by changing the proportions when ruling up and allowing extra space above and below the x-height.

If you are writing out a poem, or anything with more than three or four lines, keep your ascenders and descenders controlled as they can interrupt the flow of the whole piece if they are too long. On the other hand, elegance and charm can be added to Italic by increasing the ascenders and descenders. You will soon learn when that would be appropriate.

Task
Italic minuscules
Practice the pen play exercises first before working through the minuscule alphabet. Use your double pencil pen the first time and concentrate on the 45° pen angle. Try to maintain it happily throughout an 11 × 14in (A3) sheet of mark-making exercises.

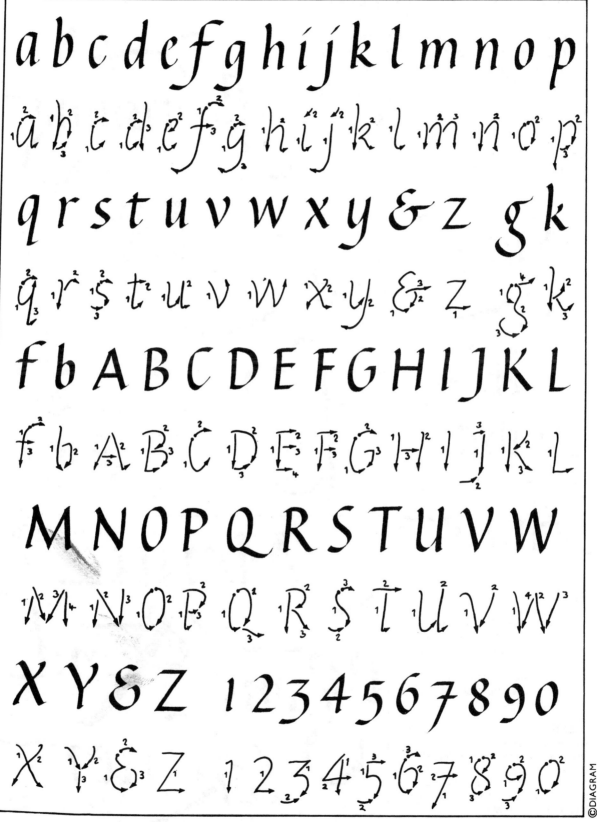

Flourishing Italic

Flourishes are extensions to ascenders, descenders and capital letters, and on the last letter of a line or a word. They are either alive, ribbon-like and effective, or tight, too condensed and distracting, so it is important to experiment and feel confident about making them. Over ornate flourishes are attention seeking and fussy, whereas successful ones delight the eye. Start with simple ribbons and aim to use them sparingly. Think of it as flicking a ribbon or cracking a whip, not as an ornate pattern.

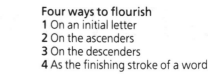

Four ways to flourish
1 On an initial letter
2 On the ascenders
3 On the descenders
4 As the finishing stroke of a word

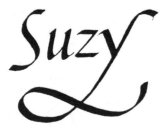

Single strokes
Some flourishes can be made in one stroke:
A A simple ribbon-like flourish
B A whipcrack flourish

A part of the word
These flourishes (*below*) are from the ends of words, and look like natural extensions of the letters. Beware of making flourishes look too "busy."

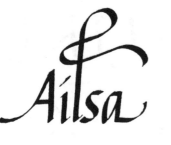

Task
Enhancing names
Analyse the flourishes on the names Suzy and Ailsa and, using various different nib sizes, learn them. Turn your work upside down to enhance ascenders too. Smaller nibs will be easier to use than large ones.

Task
Finishing strokes
Using a ¼in (6mm) line template under your layout sheets, write out an alphabetical list of girl's names and add finishing strokes that extend the word.

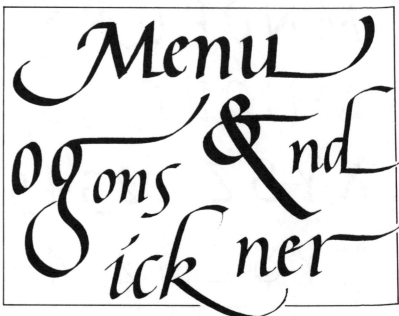

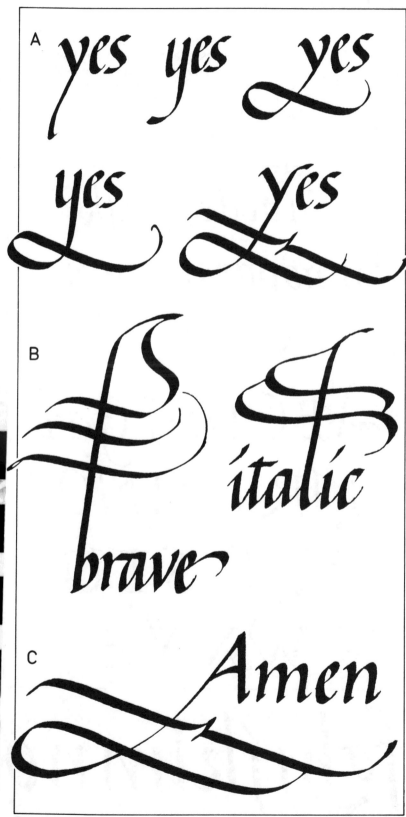

Variations

Some examples of flourishes on descenders and ascenders:

A They should be free flowing and rhythmic, but also depend on where the word appears in your work and the emphasis you want to put on it.

B Over ornate flourishes can look contrived and do not flow freely. They distract from the word and appear to seek attention. In these examples the flourishes, although ornate, are balanced by the exaggerated height of the ascender.

C Parallel strokes and diagonal stress give emphasis to a word.

Task

Developing shapes

Using every third line on your line template, write out the girl's name list again adding flourishes on ascenders and descenders. Work on improving several names to develop an interesting shape. Allow more space between writing lines for flourishes.

Task

Labels

Make a list of family and friends and write the names on thin card, using flourishes. Trim the card, leaving plenty of space, after you have completed the design to make labels. You might like to use designer colors or diluted inks.

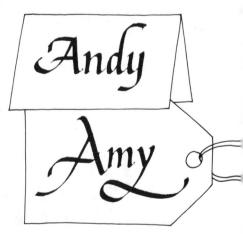

31

Variations of Italic

Italic is a generic term which covers all the variations of the style. The letterforms are formed in just the same way as formal Italic on page 29, but by changing the proportions, condensing or opening out the letters, or by making them more angular or rounded, endless variations on the theme are possible.

You can see this for yourself by taking one text and writing with swashes and a free-flowing hand. Then write it again with the angular spiky Italic that you see at the bottom of the page. The overall moods of the two pieces of writing will be surprisingly different.

Decorated Italic
This Italic alphabet uses swashes – elegant, free-flowing extensions of the letters. The capitals can be used to give vitality and charm to a piece of writing. The light and spacious quality is made by extending the ascender and the descender height of the minuscules, and opening out the capitals. The lettering should stand on its own without unnecessary additional decoration.

Task
Trial run
Write out "the quick brown fox jumps over the lazy dog" using the alphabet below. Check all your pen angles afterward using a protractor or a set square. Repeat if necessary.

Angular Italic
This lower case Italic (*below*) has an angular and spiky quality with hairlines on some ascenders and descenders.

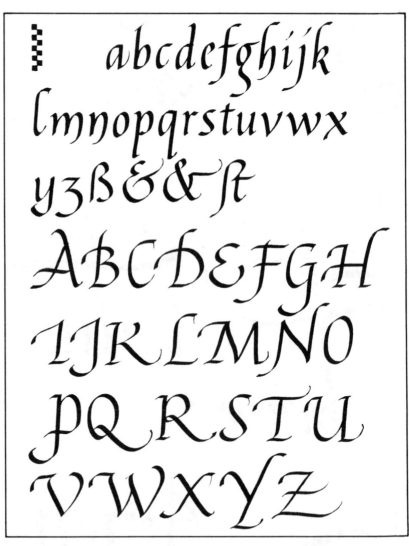

Seguita lo essempio delle lre che pono
ligarsi con tutte le sue seguenti, in tal mo=
do cioe

aa ab ac ad ae af ag ah ai ak al am an

ao ap aq ar as as at au ax ay az

Il medesimo farai con d i k l m n u.

Le ligature poi de c f s ſ t sonno

le infra =

scritte

ct, fa ff fi fm fn fo fr fu fy,

st st

ſf ſſ ſß ſt, ta te ti tm tn to tg tr tt tu

tx ty

Con le restanti littere de lo Alphabeto, che

sono, b e g h o p q r x y z z

non si deue ligar mai lra

alcuna sequente

Arrighi's Italic

An extract from the work of Ludovico Arrighi, published in Venice in 1533. Arrighi's copy books using the cursive hand had a great influence on the development of the Italic hand.

Task

Alternative Italic

Find a 2 or 3 line piece of prose and write it out in a variation of Italic, condensing, extending or adding flourishes or hairlines as you wish. Don't worry if it doesn't work the first time, just put it aside and try again. Keep writing it out until you have a satisfactory result.

Task

Formal Italic

Find a poem or a nursery rhyme of about 12 lines and write it out. You can use flourishes on the top and bottom lines if you wish. Practice before you begin, leave space around the edge of the writing, and date and sign the piece.

Task

A gift

Choose a favorite piece of prose and write it out using either Italic or Foundational hand. Give it to a friend and keep the paste-up with all the details on it to enable you to make another copy.

pqrstuvwxyz &

Italic handwriting

As you begin to develop your calligraphic skills, you might like to take a closer look at your own handwriting. Do not confuse Italic handwriting with formal Italic script. If you feel this is beginning to happen, stop one and concentrate solely on the other one for a while. Italic handwriting is a rhythmic and legible way of writing beautifully all the time. Use it as often as possible, and write checks, notes, lists and memos beautifully! Your handwriting tells everyone something about you and is a form of self-expression. The alphabet shown here is to give you a framework to build upon. Italic is a system of rhythmic movements across the page, using letterforms. The exercises are to help you build up your mark-making experience. Don't rush at it. It is possible, with practice, to write fast and well in only a few weeks.

Points to remember
- Italic handwriting uses ligatures, strokes which join one letter to another to give a continuous, fluent script. The pen stays in contact with the paper most of the time.
- Hold the pen at 45° to the writing line so that the correct distribution of thick and thin is maintained.
- Left handed people need an oblique nib in their fountain pen. It is a good idea to keep the left elbow tucked well into the body and maybe adjust the paper sideways a little.
- Try not to press hard with the pen. Some letters require you to push the pen upwards and unnecessary pressure at this stage will slow you down and cause splatters.
- The x-height of the letters is 5 nib widths. The ascenders and descenders are both 9 nib widths, and the capitals are 7 nib widths high.

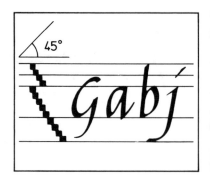

Handwriting exercises
A 45° mountains making thin and thick strokes
B Springing arches in the proportion 2:3
C Swinging-up pattern
D The pull-down stroke, the arch and the ligature (joining stroke)
E O can be made in one stroke, as can c and e
F Go through the alphabet with m as a middle letter, remembering to keep the 2:3 proportion
G Lift the pen after these letters: b, g, j, p, q, s, x, y, and before these: a, c, d, g, f, &, z
H Check the writing angle if your letters look wrong
i too steep
ii too flat
iii correct
Turn the page upside down to check your rhythm.

a b c d e f g h i j k l m

n o p q r s t u v w x y z

A B C D E F G H I J K L M

N O P Q R S T U V W X Y Z

© DIAGRAM

Task
Italic handwriting
Using two sheets of paper, rule out a diary page for one week. Write down each day's events for one week in your best writing. You can use other styles for the month and the days of the week. Use your fountain pen for the Italic handwriting.

Task
Exercises
Use guidelines ⅖in (10mm) apart as writing lines under a sheet of layout paper and, with a fountain pen, play for a while with the exercises before going on to the alphabet itself.

Task
Fountain pen or felt-tip
If you're struggling a little, use a chisel-ended felt-tip pen first and do the exercises again. Then write out a "a quick brown fox jumps over the lazy dog." If you're happy with your efforts, write it out using a fountain pen and remember to put the date on.

a quick brown fox jumps over the lazy dog

Review

These basic hands or styles are sufficient to be able to make finished pieces. You now need some technical skills which work together to give your writing a sense of organization and presentation. If ever you have a few moments to spare do some pen play. Go through your quotations notebook and write out a favorite quotation.

The Ramsay Psalter
This is the manuscript on which Edward Johnston based the Foundational hand (*below*). It is a Carolingian manuscript written in Winchester, England during the 10th century.

Trajan's Column
These majestic Roman capitals (*below*) were cut in Rome in the year AD114. They were first formed with a brush and then chiselled out of the stone.

Task
Optical illusion
If you measure the height of the letters on different lines of this example you will see that they decrease in size towards the bottom. This creates the optical illusion that all the letters are the same height when viewed from the ground. The Roman lettercutters used accurate measurement combined with subtleties like this. You too must be accurate and learn to trust your eye.

Practice line

Right, this student writes well but still needs to watch for some bad habits. Exercises like this are worth doing before you begin a proper piece of work because they help to get your hand and eye coordinated.

1 Angle too steep
2 Too rigid
3 Rigid
4 All too sharp
5 Narrow letter
6 Leaning back
7 A bit better
8 Short tail
9 Weak middle stroke

Task
Comparison

Write out a piece once in Foundational hand and once in Italic hand. Compare the two pieces.

Task
Your handwriting

Practice your handwriting for 20 minutes of each day for one week. Compare writing done on day one to writing done on day seven and see if a rhythm is developing.

Rhythm

Right, an extract from a letter to Michelangelo from his father. If you turn this upside down you will see that a few of the angles are not quite right.

Task
Review

Open your folder and take out all the signed and dated work you have done so far and pin it on the wall. Go round looking at this exhibition and examine the evidence of your learning. Be critical, and see how far you have progressed. Put away all the work except your best piece. Leave this on display until you know you can do better, then put it back in the folder.

an bn cn dn en fn
gn hn in jn kn ln m
non pn qn rn sn t
nun vn wn xn yn z

Above all things,
take care of your head and
keep it moderately warm,
and see that you never wash:
have yourself rubbed down
but do not wash

keep it moderately

Chapter 3

The nature of any mark you make depends on the tool you use. Pens are most important; basically they need to be sharp and clean. A soft cloth is essential for periodically wiping your nib clean as you work. Ink and paint can build up between the nib and the reservoir very easily. Any build-up will interfere with ink flow and your letters become blobby and lose definition. New steel nibs may well be scratchy and need attention, but become smoother through use. Shown opposite is a useful technique for improving your nibs. (Left-handers may also find this a useful tip, adding a little to the oblique angle for ease of writing.) In completing one finished piece of calligraphy you will find yourself using several of your mark-making tools. Always make a note of your nib sizes that you've used.

Task
Make a pen
Pens can be simply made using lolly pop sticks, clothes pegs or pieces of balsa wood. Glue a piece of felt around a piece of balsa wood and grip them with a bulldog clip. This creates a wide pen which is very useful for display work. Patterns can be cut into the "nib" to make decorative marks.

TECHNIQUES

This chapter is concerned with the various technical skills you will need in order to do the projects in the last chapter of this book. Designing a piece of work, developing the color scheme, pasting it up and possibly experimenting with changing the weight, style or size of the letters, are all familiar tasks to the graphic designer. Here they are all presented with clear instructions, presuming you know nothing about such technicalities! Read through the whole chapter first to familiarize yourself with the techniques. As you work through the tasks from this chapter, don't forget to continue practicing your calligraphy, that's important too!

Instructions for sharpening a steel nib

Use a fine oil stone, or if you don't have one, buy some very fine quality wet and dry abrasive paper from a hardware store. Tear off a strip of the paper and tape it down to a firm base such as a piece of wood or a corner of a work surface. Keep your nib in its holder, turn it upside down and pull the nib across the abrasive surface four or five times using firm pressure (**A**). This creates a burr on the tip which is easily removed by turning the nib back over, steepening the angle and, using a firm stroke, pulling the nib over the abrasive surface one more time (**B**). Test the result and repeat the process if necessary.

Task
Magnifying the problem
Use a small magnifying glass to check the writing tips of your steel nibs. Sometimes, too much pressure from a reservoir will force the slit open and this must be rectified by adjusting the reservoir.

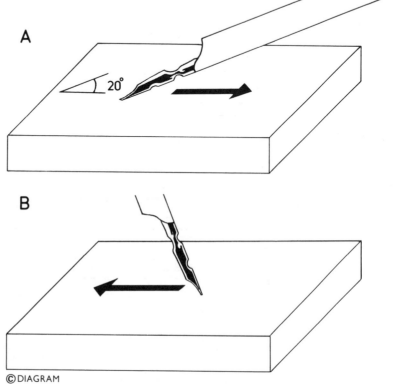

© DIAGRAM

Using templates

A template is a design aid. It is a basic pattern which helps you to make accurate repeats of the same shape. By using such devices you can save a great deal of time and reduce the risk of inaccuracy. Here you are shown four different types of templates, three of which you can make yourself. Once you have drawn them out make several copies by tracing them off or by using a photocopier. Some copiers have an enlarging and reducing facility which can be used to make copies at a variety of sizes. This way you can create a flexible range of templates which will be to hand whenever you need them. Practical aids such as these are not "cheating." Instead, they allow you to make more efficient use of your time and achieve better results, and as such they are invaluable.

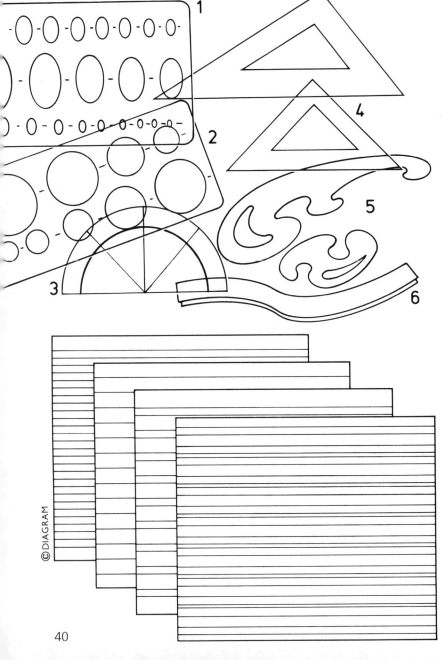

© DIAGRAM

Plastic templates
These can help when drawing both regular and free flowing curves. They can be bought from art shops. They are useful, but beware, they are sometimes expensive, so only buy ones you know you will use!
1 Ellipses
2 Circles
3 Protractor for angles and arcs
4 Triangles (set squares)
5 French curves
6 A flexicurve, plastic coated wire which will bend to any shape you wish.

Writing lines
These can be very useful if you draw them to the correct sizes for your nibs. Don't forget that you can also use them to measure space between areas of writing. You can also make up one for page layouts, leaving margins and space for illustrations.

Task
Line templates
Make a complete set of writing lines, one for each of your nib sizes, using a photocopier to enlarge and reduce the pages at the end of the book.

Task
Layout templates
Using a shape template or a paper rule, practice your Foundational hand by writing out a rhyme or poem with several stanzas. Date this piece.

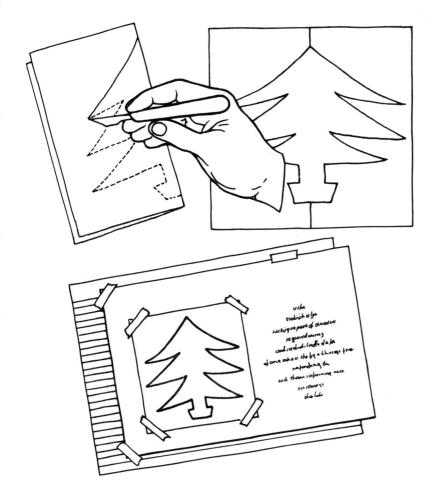

Cutting a silhouette

A silhouette template, cut from a piece of card, can be used to great effect. Using a line template along with a shape template can help a great deal when doing "production line" projects such as Christmas cards.

Task

Envelopes

Make a line template which fits inside your envelopes and practice your Italic handwriting using friends' addresses. Experiment with different layouts.

Pricking through and making a paper rule

Careful examination of old manuscripts will reveal that this method has been in use for centuries! It saved the scribes' time and ensured that all the pages of a book matched. When you have successfully completed one piece of work you can use it as a "master" by pricking through where each line starts so that the prick marks show on the pages underneath. The tiny holes can be hidden afterward by rubbing gently on the back of the paper with a fingernail. Alternatively, you can make a "ruler" from a piece of card and mark off the starting point of each line. This can then be transferred to copies and used as a guide when ruling up. Both of these methods help to eliminate inaccuracies.

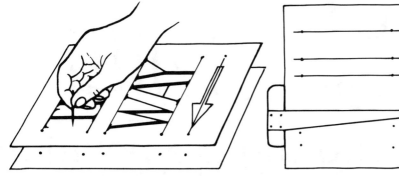

Spacing words and lines

When a typesetter finds that a line is too long he can adjust the letter spacing so that the words are more spread out or closer together. Calligraphers use other devices, including changing the letter size, overlapping letters, sharing stems, and placing letters within each other. These are all traditional options which add charm and individuality to a piece of work. You can follow in this tradition. What you have to remember is to reduce your nib size so that the smaller words have a pleasing proportion and match the rest of the text.

Letterfitting
In many ancient manuscripts, small letters were fitted inside or alongside larger ones. This was sometimes done to fill up the large counters (see page 18) of letters like L and C. Looping letters together was another way of squeezing them into a smaller space.

Task
Abbreviations
Find a piece of text and write it out in capitals. See how much you can shorten it by using abbreviations, stacking letters and writing with a smaller pen. Use the examples (*right*) to guide you.

Linespacing
Generally, a distance of twice the x-height between the lines of writing will guarantee that ascenders and descenders from one line will not touch the ascenders and descenders of the lines above and below it. On regularly ruled paper or guidelines this will simply mean using every third line as your writing line, the one above acting as the guideline for the x-heights of the letters. Increase this standard linespacing when using flourishes, swashes, decorated letters or styles such as Carolingian, which has elongated ascenders and descenders.

Spacing capitals

Space between rows of capitals can be reduced. When using capitals to issue a short instruction or message it is the space around the letters which must be maintained.

1 A clear statement
2 Shouting at the reader!
3 Wrong, because the reader "reads" the space in the middle

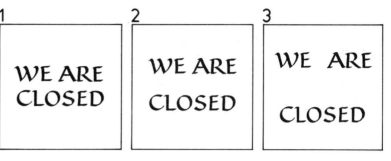

Letter and word spacing

Letterspacing will depend on what style you are using. For example, Foundational and Italic minuscules, which are "open" and rich in curves, will need more space than a Gothic hand, in which nearly all the letters have straight sides.

In general, allow only enough space for the word to flow, and remember that the space between any two letters should be governed by their shape and not by strict rules of maintaining a set distance between them (see page 20). Large headings written in capitals can be very effective.

Between words you need only allow space equivalent to a letter n. Any more, and you may find that, on half closing your eyes, "rivers" of space run down between words.

This example (*right*) is as much about space as the letters. The layout draws your eye down the page to the conclusion of the quotation. It would not work so well if space were lost above the letters. Do not be tempted to crop work and deprive it of essential space. (Dostoyevsky quotation by Lindsay Castell.)

the n quick n brown fox n jumps n over the n lazy n dog

Task
Lettering practice

Write out a poem in Italic three times using a different nib size each time. Measure the dimensions and see how they vary.

Task
Within limits

Find a quotation, a prayer or a philosophical thought and, using capitals only, change the sizes of the letters. Work within a frame of 1½in x 6in (40mm x 150mm) as if it was to be used as a bookmark.

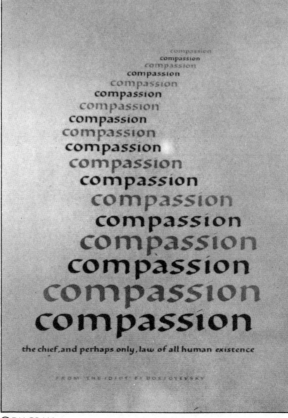

Centering

Centering lines of lettering will immediately make a piece of work look much more professional. The effort you have to make is well worth it. With details of a menu or an invitation there is a strong tradition of centering, so for demonstration purposes we show a menu in Italic, although you could equally well use Foundational. Centering can be used for poems, posters, cards or page layout.

It is very flexible as it works well with plain letters or with flourishes and illustrations. You should aim for symmetry, both of content and space, so experiment by moving lines closer together or further apart. Write out some variations, maybe using capitals for emphasis, and play with different nib sizes before you make your final decision.

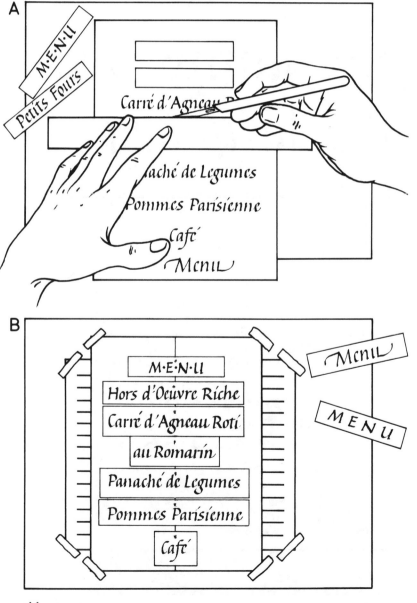

Procedure
1 Write out individual lines of writing with some variation in nib size.
2 Cut out the lines just above ascenders and just below descenders. You can cut close to your capitals (**A**).
3 Place a line template with a vertical line drawn through the center under a sheet of layout paper. Tape them at the corners.
4 Measure out each line of letters and mark the half-way point with a dot.
5 Lay the lines of writing out in the correct order with the center marks over the vertical line on your template (**B**).
6 Begin to experiment with the various options. Move lines closer together and further apart. Imagine that, instead of a series of labels, you are looking at one piece of work. Try to ignore the edges of the labels. Squinting through your eyelashes helps a little! It may be necessary to rewrite some words.

Task
Experiment 1: Text
Try this method by cutting up a nursery rhyme written in Italic or Foundational. Is there one line or a heading which will need more emphasis? Write in large letters on 11 × 14in (A3) layout paper and store this.

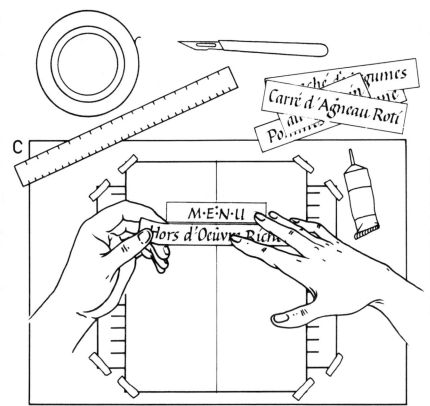

7 When you think it looks balanced secure each piece of paper with a tiny amount of paper glue (**C**). Place a piece of glass over the whole thing (use some from an old picture frame, if possible). The weight of the glass flattens the paper and makes the words read more clearly.

8 Make more adjustments if necessary. Place pieces of card in a neutral color around the edges to judge the correct amount of space around the words (**D**). Remove the glass and mark the corner points. Do a final paste-up when you are satisfied, sticking the labels firmly to the layout paper. Measure with dividers for accuracy.

9 Place this rough version on top of a piece of good paper and, using a pin, prick through at the ends of each line.

10 Write out carefully, but try not to tense up because it will show in the letters. Relax and enjoy the writing.

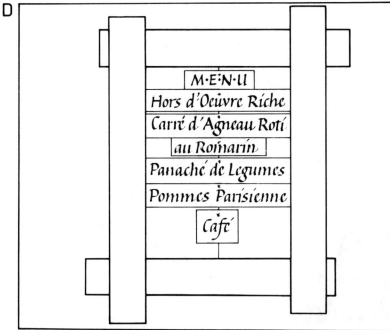

Task
Experiment 2: Poster
Imagine you have a poster to do. You will need an event, date, time, venue, prices etc. Use a variety of letters: all capitals; all minuscules; a mixture of the two; some heavyweight; some lightweight. Use an Automatic or Coit pen if possible. Center the words and juggle with space around them. Use 11 × 14in (A3) paper as this is a good size. Take it as far as the paste-up stage and store safely for reference.

Task
Experiment 3: Invitation
Imagine a family event such as a baptism, a wedding or a Bar Mitzvah. Using Italic, center the design and add flourishes to the top and bottom lines. Work to the paste up stage and store safely for reference.

Layout

Designing is decision making! Calligraphers, like actors, are interpreters of someone else's words. Therefore, it is important to read through anything before you write it out so that you can pick out the subtleties, humor, pathos, energy or any other human emotion which may lie within it. Remember, whatever is being expressed, it must be done so LEGIBLY. Your main objective is to render clearly your understanding of the author's words.

Alignment

There are five basic ways of aligning text:

A Justified; both the right and the left hand edges form a straight line
B Ranged left or flush left; the left hand side forms a straight line
C Ranged right or flush right; the right hand side forms a straight line
D Centered; the lines are uneven in length – but the layout is symmetrical
E Asymmetric; the lines are not aligned and are freely positioned

A

DOMINA MEA
Sancta Maria, me in tuam bene-dictam fidem, ac singulârem custô-diam(& in finum misericordiæ tuæ, hódie, & quotidie. & in hora éxitus mei, & animam meam, & corpus meum tibi commendo: om-nem fpem meam & confolatiônem meam, om-nes anguftias & miférias meas, vitam & finem vitæ meæ tibi cominitto; ut per tuam fanctiffi-mam interceffiônem, & per tua merita, ómnia mea dirigintur, & difponántur ópera fecun-dum tuam, tuique Filij voluntâtem. Amen

B

Eccellentiffimo. M. Giouanni padre uro ʃxete illuftre, col fauore uniuerfale di Questa Illma Republica p le ʃue degne operationi ʃan alla altezza de gran. secretariato, e ʃalito ʃene ʃi come ʃempre fatto hauea, uiʃʃe ʃantiʃʃimamente: non doura p cio eʃer diʃcaro che io gli accenda quel tanto di lume col donaruoʃi questa mia operetta, quanto con le mie piccole forze ʃi e p o tuto il maggiore. A dunque non ʃdegnate Magnifico ʃignore mio di prendere queʃto mio libretto in dono, come

C

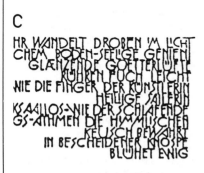

D

Et perche de tutte le littere de lo
Alphabeto, alcune ʃe fanno in uno
tratto ʃenza leuare
la penna deʃopra la carta, alcune in
dui tratti
Mi e parʃo al propoʃito dirti, quali
ʃomo quelle che con uno, quali gl'

E

Where do you start designing?

1 Start with the words and decide which style to write in. Then look at line length. The meaning of the text should not be lost by breaking up lines in inappropriate places.
2 Consider the arrangement of the lines. Are they already in stanzas or paragraphs? Let the words speak for themselves; don't attempt a fancy arrangement for its own sake, even though it can be tempting. Consider overall size, taking into account where the work is to be positioned.
3 Consider whether color will add to the meaning of the words. Can it be used to convey your interpretation of the words? Are there any restrictions or obligations regarding color as far as the recipient is concerned (if the work is to be a present)? Using colored, textured or tinted paper should also be considered at this stage.
4 Will you need to divide up the text, use a translation or give any additional information? Would using more than one size of pen or using small capitals help with this?
5 Is there a logo, a heraldic shield, a flag or an illlustration to go with the text? Sometimes a simple pen drawing, or a watercolor sketch, goes well with calligraphy. Don't try to be an artist though!
6 Don't be rushed into settling for the first ideas you have. Although they are often good you must explore other variations and possibly reject them, as part of the design process. Do several rough sketches of the layout at an early stage and discuss them with other people if that will help you. Criticism can be hard to take later on if you have written the whole thing out, but inviting constructive comment BEFORE writing means that you can incorporate other ideas if they're good ones. Alternatively, put your designs up on a door or a wall for a day or so and keep looking at them. As you become more objective your value judgements are less impaired and you can become your own best critic!

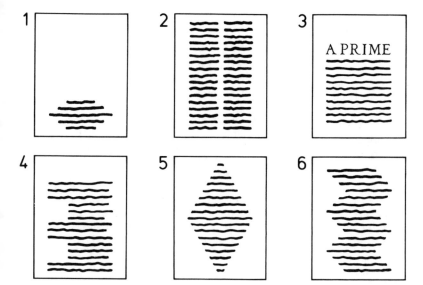

Interesting layouts

Refer to historical manuscripts and various cultural sources when considering layouts. Below, some of the many variations:

1 Use space to focus attention onto the letters. This device is frequently used in Eastern art.

2 If you have a large text, try splitting it into two columns. Bibles and some secular manuscripts were often done this way.

3 Embellish the opening of your text with large words. This was often done in Bibles and manuscript books.

4 Stagger the work quite freely. This would be appropriate for a humorous quotation or a lyrical rhyme.

5 and 6 Use geometric shapes to give structure and add to the image.

True
ease in
writing comes
from art, not chance,
As those move easiest
who have learn'd
to dance

Alexander Pope

Alternative layouts

If you have just one large word, name or sentence to letter on a page, this can be your chance to do some really dramatic calligraphy *(left)*.

Task
Headings

These can be varied in weight and in so doing you will alter the whole balance of a piece. Write out a nursery rhyme in Foundational. Above it draw lines ½in (10-15mm) apart as your writing line and x-height. Write the title with three different nibs keeping the same height. Compare the results.

Task
Balance

Experiment with various nibs and pens by writing headings between a pair of lines and then fitting the different results to some 4 or 5 lines of writing. Can you achieve a balance between heading and text?

Pasting up

As its name implies, a paste-up is a design rough, in which the different elements of the design are stuck down in their correct positions on one background sheet. It may be black and white or colored, and should include everything you want to appear on the final version, including text and illustrations, if there are any. The ability to produce a good paste-up is very useful, and takes a certain amount of practice, so do not worry if your early attempts are rather rough.

There are three basic reasons for doing a paste-up. First, as a reference for yourself during the production of a piece of work. Second, you might use one as a visual, that is, as a way of showing how the final piece of work will look to yourself or another person. Finally, a paste-up is also the last stage of a piece of work before going to press, if the work is to be printed.

Task
Experimentation
Cut up some spare pieces of writing you may have into lines and paste them down onto a clean sheet creating a variety of different layouts with the same words. Using paste-up in this way is a simple method of experimenting with layout.

Task
Reproducing work
Choose a favorite piece of prose, write it out in either Italic or Foundational hand, cut it up and make a paste-up of it creating an interesting layout. Transfer the measurements and sizes from the paste-up to a clean sheet and write out the new design. Repeat this last stage again and see how similar the two finished pieces appear. Store the paste-up and repeat the process again in a month's time.

Task
Trial run
Paste up a sample card using a motif and a simple message. Take it to a photocopying shop and have several copies made.

1 Paste-ups for reference
Producing a paste-up is a way of seeing whether your design will work before you actually settle down to do your best copy. By writing out all the text at the intended size and with the intended nib, and producing illustrations if necessary, you can judge whether you need to make any adjustments. When you have decided on your final design you can transfer the sizes and shapes to a good copy by a number of processes.
● Pricking through (1) involves laying the paste-up over a piece of paper and pricking the paper with a pin or other sharp point to mark where each line appears. By doing this you can make a number of copies identical.
● An alternative method is to use dividers (2) to transfer measurements from the paste up to the 'good' copy.
● You can also make a measuring ruler (3) to transfer the measurements. This consists of a piece of card which is held against the paste-up and on which the positions of the lines are ticked off. The "ruler" is then held against the new copy and these positions are transferred. Remember to keep a record of the nib sizes and colors used.

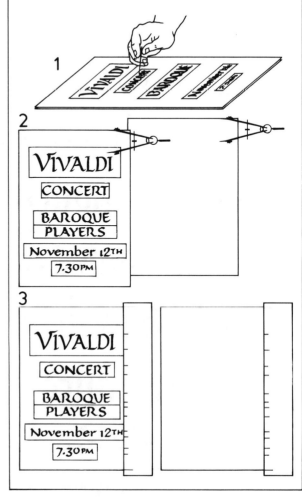

2 Paste-ups for consideration

A paste-up can be used as a "visual", that is, a representation of the way the finished piece of work will appear. If you have several possible designs and cannot decide which to use, or if you want to try the same design with a variety of color combinations, then make a paste-up of each. Put them all side by side and seek a friend's advice (or a client's opinion, if you have been asked to do the work for someone else) so that the designs which do not work are eliminated at this stage.

3 Paste-ups for printing

If you have a large print run, you may decide to use the services of a professional printer. If your print run is small, however, you may find that a photocopying shop can work out cheaper. Either way you will need to produce a neat, clean, accurate paste-up. Use thick paper or board as the base for the paste-up, and protect the paste-up with a piece of tracing paper fixed over the top with tape down one side (an overlay). Use typewriter correction fluid around the edges of your pasted down paper, otherwise you may get shadows. Test this by photocopying the paste-up.

 Preparing work for printing in more than one color is a slightly more complex procedure. The most common way of doing this is by separating the paste-up onto overlays, each overlay printing a different color. A baseboard is used – usually thick card or board for the "majority" color – usually black – and the additional pieces to print in color are pasted onto transparent plastic film, hinged to one side with tape, and in register with each other (see illustration *below*).

Baseboard: 1st color
Overlay 1: 2nd color
Overlay 2: 3rd color

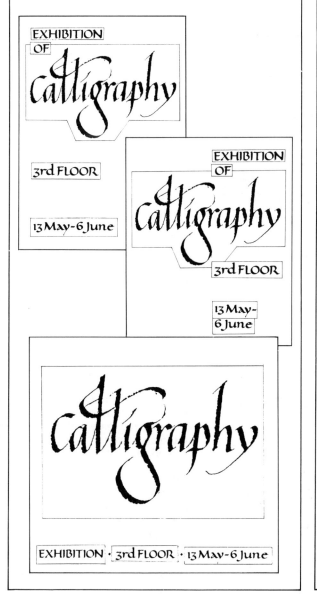

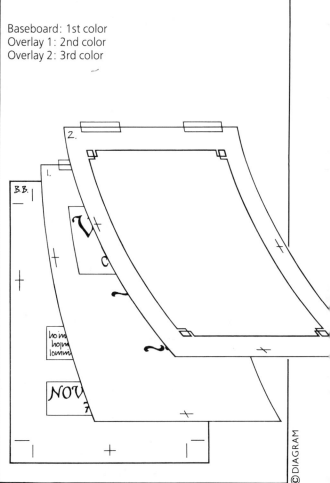

Using color

There is one simple rule which must always be followed when mixing paint – add the water to the paint, not vice versa. This rule applies regardless of whether you use tubes, jars or cakes of paint. You might find it useful to keep colors such as vermilion and white in screw top jars, just as ink is. This might encourage you to use them more. If you dilute some black fountain pen inks in the proportion of one part ink to three parts water you will get a gentle grey blue tint which is very subtle and effective. Reducing the length of the handle on your brushes can prevent accidents with paint and securing palettes and ink pots with Blu Tak also helps. Use the brush as a measure for the paint and dilute with drops of distilled water from a dropper bottle. A couple of smears of egg yolk in vermilion will make the color more vibrant and add permanency. When working on a long piece of work you must remember to add water to the paint as it will evaporate and will not flow through the nib well. Aim for a milky consistency when mixing paint whether you're writing with a pen or simply flooding in an area with a fine sable brush.

A

B

Traditional use of color

Headings and the initial letters of a stanza or verse are often red. Vermilion and spectrum red are strong colors which contrast dramatically when used along with traditional black ink. Red gives warmth to your work and claims attention, so use it on names, initials and anywhere that you want emphasis.

A These initials would look arresting in red with black text.

B The warmth of red contrasts well with the cool effect of blue and green. Alternating these three colors down a page in the traditional manner produces a balanced effect.

Task
Red and black
Write a poem or a piece of text in Italic using black ink and add a vermilion heading either in capitals alone or in majuscules and minuscules together.

Task
One, two, buckle my shoe
Find a piece of text which is like a list (for example, a counting rhyme). Write it out using alternating colors in the following sequence: red, blue, red, green and so on. Develop this into a finished piece and date it.

Task
A card for a friend
Write out a birthday or Christmas card to a friend with alternating green and blue words, and give it to that person on the date. You can also produce interesting effects if you use a textured paper.

Some newer ways of using color
Instructions
1 Choose a large nib and rule up a line template with gaps alternating from ⅖in (10mm) to 1/10in (2mm) as shown.
2 Put the template under a sheet of layout paper or a lightweight paper.

3 Using either green or blue ink, mix 3 bowls of tint: one watery (bowl 1), one stronger than this but still diluted (bowl 2), and one undiluted (bowl 3).
4 Choose a single word which has both an ascender and a descender and write it repeatedly in the ⅖in (10mm) space (this distance being the full x-height of the letters). Load your

pen from the bowls in sequence 1,2,1,3,1,2,1,3,1 and so on to achieve a subtle effect.
5 Stagger the starting points of the lines and do not give the ascender its serif or the descender its final stroke.
6 Do not worry about the overlapping of letters, this is part of the effect of using watery tints.

Splattering
This can be a very effective way of decorating a humorous quotation. Use a diffuser containing waterproof ink or a watery mixture of paint. Fix the paper in a vertical position while you're working on it, but lay it flat to dry. Keep the angle of the diffuser at 90°. Don't overspray or the ink will run. Purse your lips tightly and blow long and hard. This technique can also be used to apply art fixative if you dislike using aerosols. Diffusers are readily available from art shops.

Task
Splattering
Write out a humorous quotation and splatter some bright color over it. Try several versions of this simple idea and display the most successful ones.

©DIAGRAM

Problems

There are numerous problems that can arise when learning calligraphy. These two pages show the possible solutions to the most likely ones.

The stroke not sharp on the paper
Your forefinger or thumb is pressing too hard and you're not placing the nib squarely to the paper. The nib may need attention. Try a few pulling strokes on very fine sandpaper. Finish off with a sideways stroke once each way.

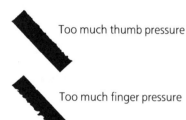

Too much thumb pressure

Too much finger pressure

Trouble with ink blobbing
Did you degrease the nib and the reservoir before writing? Either lick them or pass them through a flame to degrease. Your pen angle or the angle of the drawing board might need adjusting. Remember that the angle of the pen to the paper should be 90°.

The ink won't flow
This could be due to a number of causes: rusty nib and reservoir, dirty and blocked-up nib, stale ink that needs a few drops of distilled water, paint too thick, reservoir too tight and distorting nib, angle of pen to paper too low.

The ink 'bleeds' on the paper
Change ink or paper. Try protecting the surface with a brand solution bought from an art stockist.

The writing hand aches
You're trying too hard. RELAX. Take some refreshment, put on some soothing music and try some pen play.

The color smudges
Spray finished work with fixative (or even hairspray). Add a couple of drops of pure egg yolk (no white!) to the color – too much leads to cracking later.

Back, shoulders, and knees ache
Too tense – your writing will show this tension. Check height of table, chair and writing area.

The new nib scratches
A few pulling strokes on very fine sandpaper should help. Don't be tempted to press harder. After half an hour it should be eased for you.

The letters look careless
You are using the pen like a paintbrush! Instead, use it precisely, as you would a screwdriver or a chisel and try to be more precise about starting and finishing strokes.

The letters look childlike and stiff
You're trying too hard! Check your knowledge of stroke order before you start a letter. Don't read from the book stroke by stroke.

Double letters look clumsy
Remember to create them as a pair although this doesn't necessarily mean making them both identical. You could add a swash or flourish to one of the pair.

bubble

bubble

bubble

bubble

little

Certain letters always look wrong
Trace from the book the correct shape and try to *feel* what it is like to make that shape, then try again. Practice words with those problem letters with a dry pen, don't avoid them. Never do a long row of them, construct words instead, and check the stroke order with the book. Also, check your writing angle.

The letters look odd
Check with the skeleton alphabet. Are the proportions of your letters correct? Is your pen at the wrong angle? Thick and thin strokes show up this fault very clearly. Are you changing the angle?

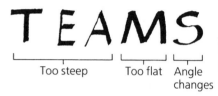

Too steep Too flat Angle changes

The letters change size
Rule a top line for a while, either an x-height or capital height, so that you get used to the size. Practice capital letters in a short quotation.

The letters lean backward
Check your sitting position. Are your legs crossed? Is the paper in front of you, or a little to one side? This is a common occurrence with left-hand writing.

The descender of line A hits the ascender of line B
Reduce your descenders by a fraction, or leave off the last stroke, and only add it when the next line is written and space for it is there. Alternatively, leave a fraction more space between lines.

Double ascenders and descenders look odd
Play with the word and find an acceptable pattern and shape for the word. If in any doubt keep it simple.

The letters don't look even
Add some upright or angled lines to the practice sheet lines and let them guide your eye to establish an even look. It will come with practice.

The poem needs illustration and you don't draw
Use dried flowers or cut out silhouettes, use designs from designers' reference books and don't attempt to be original. Ask an artistic friend to paint or draw an illustration to accompany your calligraphy. Several famous scribes have worked in this way.

Your poem is very long or would make an oddly-shaped piece
Divide it up into sections and place a section at a time on each page of a hand-made booklet or a long piece of card folded into a concertina.
You could also split it into two and arrange it like the double-spread of an open book.

The poem looks lop-sided; straight on the left hand side and very uneven lengths of line on the right hand side.
Stagger the right hand side using two margins and try indenting, or push out the first initial to lose the power of the straight left hand side. Keep plenty of space around the work so that the frame line does not echo the left hand side straight edge.

The poster looks too busy
Edit the information whenever possible, then write out everything. Take it to a photocopier to reduce it down in size and do a paste-up. Work to create space. Try very small capitals for details in tight rows and large minuscules for the main caption.

There's a lot to write and you're afraid you'll make a mistake
Divide up the project and tackle it bit by bit. Do the hardest thing first (letter cutters do). Sometimes ruling-up a second piece of paper ready to do a second attempt will help you to relax. Don't leave work until the last minute – rushing is fatal.

It's difficult to find time to practice
Make time. Try doodling with felt pens and a sketch pad whenever there's a moment. Put on some music and allow yourself just half an hour. Stop trying to find a free day – they're very rare!

Task
Double letters
Practice your Italic with a string of words, all of which contain double letters. Write each word twice; the second version should be an improvement on the first.

Task
Pen play
Play with a nib size or a pen which you don't like much in order to get the feel of it. If the nib is too rough throw it away. Check the writing angle and do some designs and doodling.

Task
No ideas?
It is important to have sources for your work. Collect postcards from museums and shops, old greetings cards, advertisements, packaging etc. Organize some files and boxes and start a collection. Use a filing system if possible.

Task
New material
If you are practicing your calligraphy it is important to have texts that interest you, so collect quotations and poems. Reread some poems you have not read for some time. Try out a few new poets and look into works of philosophy. Second hand bookshops are good hunting grounds.

Review

In this chapter we have considered techniques which you will need to know before you start some project work. Color schemes, layouts and paste-ups should now be familiar phrases to you. If you've experimented with these techniques by following the tasks you will be confident about starting projects. Techniques vary from person to person, and you will gradually develop your own way of working.

Alphabet in a circle
John Weber designed this logotype, intended for personal stationery, using both pen marks and letters. Half close your eyes and you will see how well the black marks balance with the white space between them. This is an idea you could use to create interesting designs. Draw a variety of open shapes lightly in pencil and fill in using both large and small nibs.

Task
Dramatic impact
Choose one word and letter it in various sizes, using various pens and nibs. Cut out the words and paste them down onto sheets of paper in dramatic positions. Consider several designs and gradually eliminate all but one. Store it safely for reference.

Task
Review
Get out all the work you have done so far. See how much you have learned and how much better your work is than at the beginning.

Task
Edge markers
Cut four long pieces of card with one side a light color, the other dark. These can be used as an adjustable frame to work out edges in project work. See page 45.

C H O R U S

IN AN OLD HOUSE there is always listening, and more is heard than is spoken.

And what is spoken remains in the room, waiting for the future to hear it.

And whatever happens began in the past, and presses hard on the future.

The agony in the curtained bedroom, whether of birth or of dying,

Gathers in to itself all the voices of the past, and projects them into the future.

The treble voices on the lawn

The mowing of hay in summer

The dogs and the old pony

The stumble and the wail of little pain

The chopping of wood in autumn

And the singing in the kitchen

And the steps at night in the corridor

The moment of sudden loathing

And the season of stifled sorrow

The whisper, the transparent deception

The keeping up of appearances

The making the best of a bad job

All twined and tangled together, all are recorded.

There is no avoiding these things

And we know nothing of exorcism

And whether in Argos or England

There are certain inflexible laws

Unalterable, in the nature of music.

There is nothing at all to be done about it,

There is nothing to do about anything,

And now it is nearly time for the news

We must listen to the weather report

And the international catastrophes.

from "THE FAMILY REUNION" by T.S. Eliot OM

Layout technique

Here the scribe John Woodcock has used Italic and Foundational together. In the opening paragraph he has used the traditional technique of extending the initial letter and continuing to use majuscules for the opening phrase. Balance has been achieved with the Foundational hand by alternating between two left hand margins (staggering; see page 53). Notice the interlinear space which enables the reader to see the rhythm of the language. At the bottom you can see a colophon. This balances the whole piece and also serves to tell the reader where the text comes from and who the author is. It is common courtesy for a scribe to do this at the end of a piece. Modern calligraphers sometimes add their own initials and the Latin word "scripsit," meaning "I wrote it." If a piece of work is written for someone in particular, the recipient's initials can also be added at this point.

Task
Staggered margins
Find a piece of text at least 14 lines long. Write it out once with a straight left hand margin. Photocopy it and paste it up using a staggered margin. Compare the two layouts.

Task
Balanced headings
With the text you used for the previous task, create four different headings using majuscules, color, bold letters and decoration. Put each heading in turn against the piece of text and see which ones work best. Repeat this using the staggered version. Does one heading suit both, or do they have different effects?

© DIAGRAM

Chapter 4

It's very important when you complete a project to leave enough space around it. You might need it to be trimmed before framing, but you won't make this decision till later. An experienced frame maker will discuss with you the suitable types of frame. You can also choose from a selection of card what mount to use. It's quite usual for the mount to echo one of the colors in the artwork. Delicate calligraphy does not need an elaborate frame. These finishing touches are best made in consultation with others; an objective viewpoint is very valuable in this situation.

The power of letters

This lively version of the Italic hand by Peter Thornton celebrates the joy of lettering and proves that you need no greater text than the alphabet itself. Try to avoid writing silly trite quotations, but, on the other hand, don't be over ambitious with early project work. Do not copy other scribes' interpretations of texts. Develop your own versions and don't be surprised if you find you have several ideas for the same text.

Task
Project folder
Buy two large pieces of strong card and heavy adhesive tape. Place both pieces of card on the floor leaving a ¾in (20mm) gap between their long edges. Join them together with the carpet tape. Put tape all around the edges of the card, leaving one long edge open. This is now a safe place to keep all your project work.

Task
Restock
Replace any paper supplies, inks or nibs you need. Throw out rusty or awkward nibs. Buy a new craft (X-Acto) knife or blade, if you need one. Replace tired felt tip pens and make sure your quotation book is being used.

Task
Resource box
Find a box and start to collect samples of lettering from magazines and newspapers. This will be useful later when you're looking for inspiration.

PROJECTS

In this section of the book are eight projects, two of which involve print, all of which can be successfully completed by someone who still refers to himself as a beginner. Finishing a piece is part of the creative process, and until something is in the post, hanging on a wall or has been given away, it has not been completely finished. Calligraphy is to be read by others and that often only happens when the piece is completely finished.

The projects are varied, ranging from the very simple to the more challenging, so you need to be well organized. You can do these projects again and again

introducing new color schemes, alternative writing styles, and different texts to develop your calligraphic skills further. Practice your letters, continue to doodle and experiment, but from now on, work on completing projects to show to others.

Keep decorative pens for posters and projects where you are mainly celebrating the scope of the tool. When you write out poetry, philosophy, prayers and formal pieces you are almost completely involved in expressing that text. Try to keep the two apart at this stage.

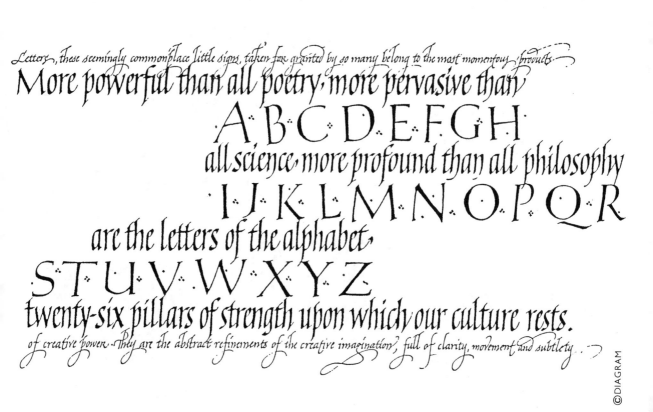

Letters, these seemingly commonplace little signs, taken for granted by so many belong to the most momentous products

More powerful than all poetry, more pervasive than

A B C D E F G H

all science, more profound than all philosophy

I J K L M N O P Q R

are the letters of the alphabet,

S T U V W X Y Z

twenty-six pillars of strength upon which our culture rests.

of creative power. They are the abstract refinements of the creative imagination, full of clarity, movement and subtlety.

©DIAGRAM

57

Labelling

This will give you many opportunities to use your calligraphy. Sometimes people will want your writing on something rather than their own. At other times it is more appropriate to have a calligrapher than a printer. Labelling can be used for: public notices, ex libris tickets, book marks, room name plates, conference plans, table place names, filing systems, storage in the kitchen, classroom or workplace, gift tags, drink labels, simple instructions, displays of merchandise and many other things. Take every opportunity that presents itself, and enjoy it!

The key points to consider when labelling:
- How is the label to be attached? Is it to be written on sticky paper, covered in transparent film, tied on with ribbon or string, standing by itself, hung up?
- Clarity of message
Would color be appropriate? Have you remembered to use different sizes of lettering, large for attention, small for detail? Have you left enough space around the message? Is the lettering in the appropriate style? Does the surface need protecting with fixative, sealant or a cover? Is it to be framed or mounted? Have you used the correct weight paper or card?
- Size
Always work out the size your labels need to be first. Write out the words (to less than your maximum label size) in the middle of a sheet of paper and trim afterwards, centering them, or positioning them as necessary.

Task
Book plates
Using a simple border from a reference book as a frame, write out your name, address and telephone number. Work in one quarter of a sheet so that you can photocopy four at a time. Reduce the design to six per sheet for smaller books. Stick into books using a line of paper glue along the top edge.

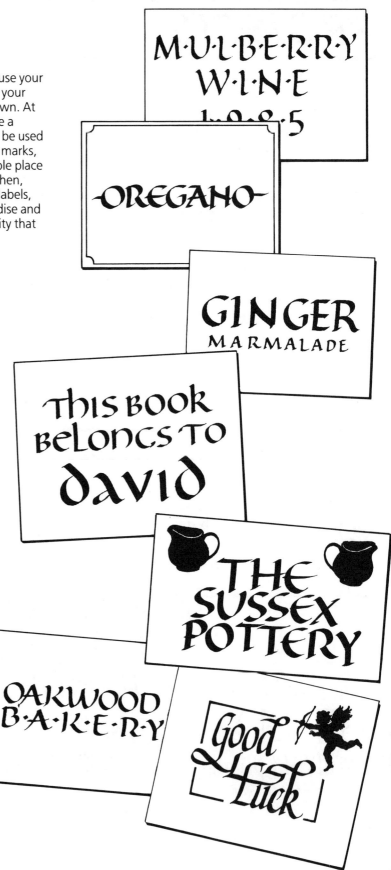

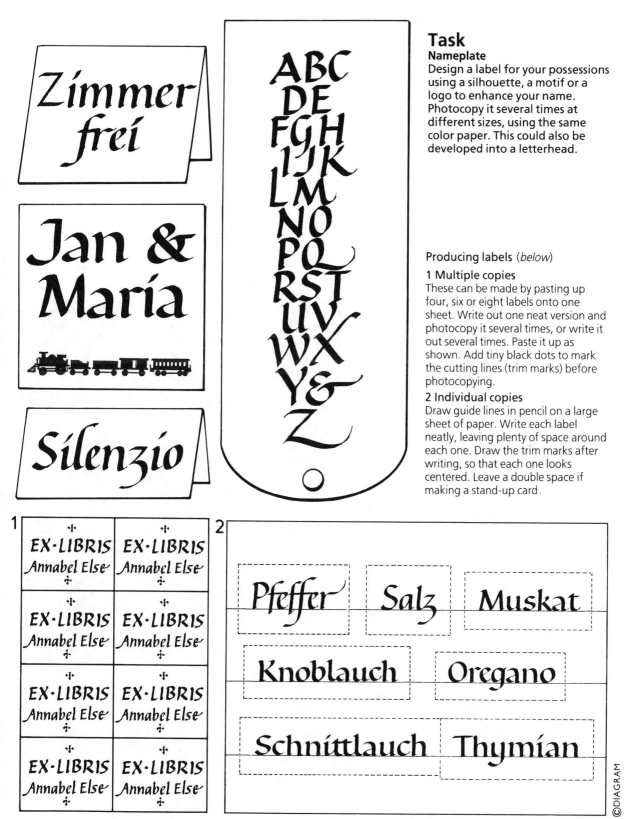

Zimmer frei

Jan & María

Silenzio

ABC DE FGH IJK LM MN NO PQ RST UV WX Y& Z

Task
Nameplate
Design a label for your possessions using a silhouette, a motif or a logo to enhance your name. Photocopy it several times at different sizes, using the same color paper. This could also be developed into a letterhead.

Producing labels (below)

1 Multiple copies
These can be made by pasting up four, six or eight labels onto one sheet. Write out one neat version and photocopy it several times, or write it out several times. Paste it up as shown. Add tiny black dots to mark the cutting lines (trim marks) before photocopying.

2 Individual copies
Draw guide lines in pencil on a large sheet of paper. Write each label neatly, leaving plenty of space around each one. Draw the trim marks after writing, so that each one looks centered. Leave a double space if making a stand-up card.

1

⋆ EX·LIBRIS *Annabel Else* ⋆	⋆ EX·LIBRIS *Annabel Else* ⋆
⋆ EX·LIBRIS *Annabel Else* ⋆	⋆ EX·LIBRIS *Annabel Else* ⋆
⋆ EX·LIBRIS *Annabel Else* ⋆	⋆ EX·LIBRIS *Annabel Else* ⋆
⋆ EX·LIBRIS *Annabel Else* ⋆	⋆ EX·LIBRIS *Annabel Else* ⋆

2

Pfeffer Salz Muskat

Knoblauch Oregano

Schnittlauch Thymian

©DIAGRAM

Giftwrap

This simple project combines two important aspects of calligraphy. First, the need to practice and get rhythm into your writing, and second, to progress to the stage where you can give your calligraphy away. You need an 18 × 24in (A2) layout pad, as smaller paper isn't big enough for wrapping most presents. Don't worry about buying such a large pad, because you can always cut it down if you want to work at a smaller size. Practice with the larger nibs in your collection, and with the decorative ones. An 18 × 24in (A2) paper is also a good size for working out poster designs, and for gaining confidence in using larger letters. If you do make a mistake, ignore it and continue writing, don't try to scratch it out.

Additions
To filled sheets of rhythmic writing you only need to add a dash of color and matching ribbon to get a very sophisticated effect.
● Color in the counters (the inside shape of the letter) with felt tip pens.
● Add lines of color between the writing lines.
● Add gold, silver, or multicolored stars and dots using stationery stickers.
● Add gold or silver with instant pens.
● Reduce a large design down to a small size for smaller gifts. Don't enlarge small writing as it will expose faults-whereas reduction hides them!
● Pen play designs provide an alternative to letters.

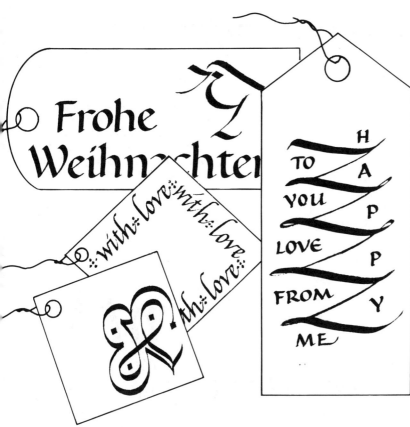

Task
Filling the page
Try to fill a whole page from edge to edge. It can be people's names, a long poem, or a stream of consciousness. Store your practice sheets and decorate when needed.

Task
Color
Build up supplies of wrapping paper by practicing Italic with a range of nibs and pens. Reduce down for small gifts. Store safely.

Task
Borders
Instead of letters, make borders based on letters. Feel free to turn the page round as you work. Fill the whole sheet with ideas. Photocopy the best ones for future reference.

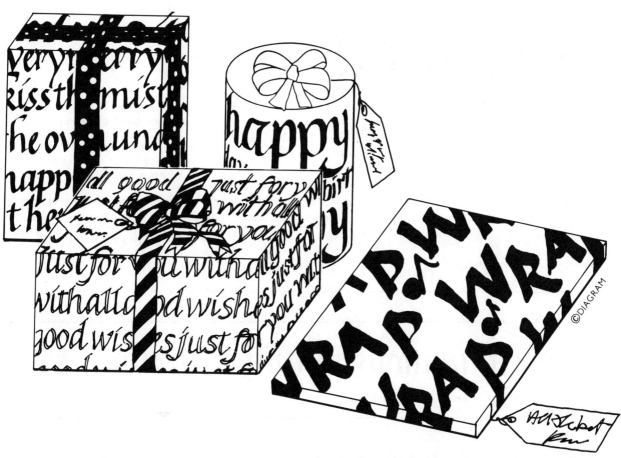

Greetings cards: handmade

The one thing that a calligrapher can do with a greetings card that a printer cannot do is put the recipient's name on it. The card can be personalized by using a familiar quotation, a nickname or sharing a private joke. Calligraphy has a lot to offer here. Use the opportunity to say something personal with a handmade card and envelope. You may find that friends ask you to make cards for occasions such as 18th and 21st birthday celebrations, retirements and other occasions when congratulations are in order. These personal communications can be very enjoyable.

Task
Cards for friends
Go through your calendar and make a list of birthdays and anniversaries for which you will need cards. Store each card safely when finished. This way you can work without the pressure of a deadline.

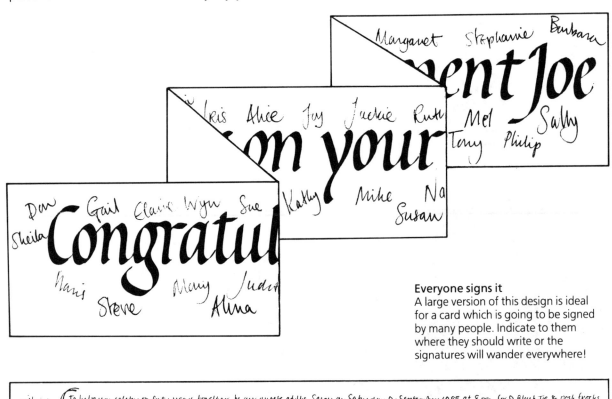

Everyone signs it
A large version of this design is ideal for a card which is going to be signed by many people. Indicate to them where they should write or the signatures will wander everywhere!

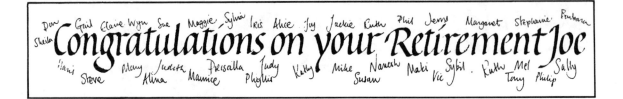

Suggested procedure

1 Use stiff thick paper or Fabriano HP paper. (This is made with 50% cotton and is quite heavy). Cut the sheet into strips, each 4in (100mm) deep. Draw writing lines along the length of each strip.

2 Make a pencil sketch of your idea on a strip of layout paper.

3 Fold the rough version of the design as in the diagram.

4 Write out your message on the card leaving 1¼in (30mm) clear space before you begin the first letter. When you have finished, trim off all but 1¼in (30mm) at the other end.

5 Measure the length of the card. Divide it into folded sections. It can be in four, six or even eight sections. Make sure that the beginning of the message is on the outside.

6 Write an envelope to match the color scheme. Use art fixative to protect the letters. Always buy a few spare commemorative stamps when they come out to use on special envelopes like this, they look much more attractive than ordinary ones! If you have a large envelope you could try using sealing wax, it would suggest that there is something special inside.

● You can make a very long card by joining two strips of card together with tape and treating the join as a fold.

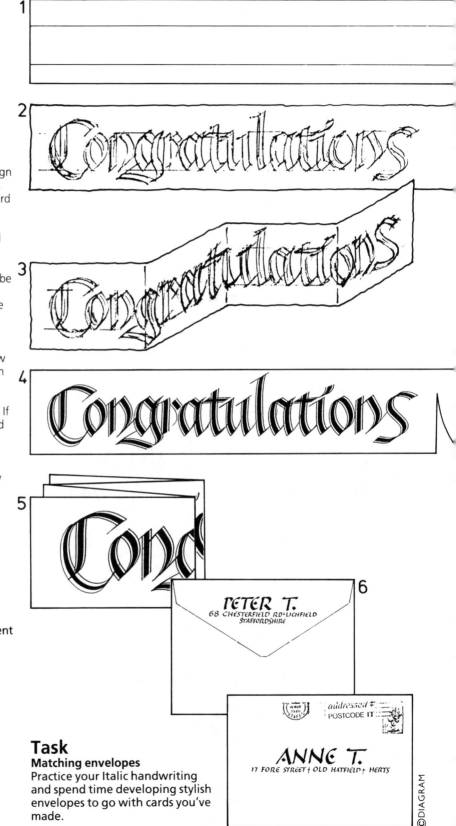

Task
Trial run
Try out this formula for a greetings card BEFORE you actually need the card. Experiment with sizes, nibs, colored ink and papers. Use capitals, Italic and roundhand. Keep these as a reference for when you make a real card.

Task
Color designs
Using color, design some long cards for friends. Include dates and names where possible. Use decorative inks, nibs and flourishes. Go back to your resource box for inspiration.

Task
Matching envelopes
Practice your Italic handwriting and spend time developing stylish envelopes to go with cards you've made.

©DIAGRAM

Greetings cards: printed

If you have any of your calligraphy reproduced, make sure you do it well, as multiple copies of a badly formed design or clumsy letters are hard to live with! Spend as much time as possible getting the details right, before going to the printer. On the other hand do not be discouraged from trying a small print run – it's good fun, and you can learn a great deal from it.

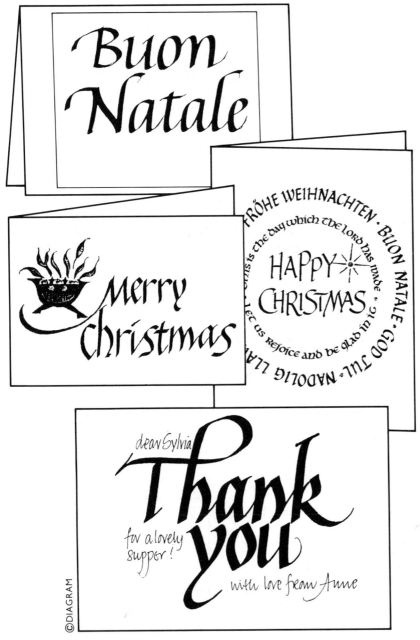

Design tips
There are a few points you should bear in mind as you design:
● As your design will end up being pasted together you can break it down into its elements at the beginning. This way you can concentrate on each one individually, then match them together later.
● Do a couple of photocopies of your final design before printing. This will show up any faults in positioning.
● Plan the colors at the design stage, not as an afterthought. Colors are more significant than merely brightness or contrast. Try to use the color sensitively.
● Consider if you want to use paper or card to print on. This may affect the way you do the paste-up as paper needs to be folded more than card to give it stiffness.
● Use decorative pens and interesting letterforms. Use color sparingly and refer to pages 46–47 and 62–63 before you start projects.

Task
Adding color after printing
Work out a card design and print it in black. After folding, add color by hand. Keep changing the color so that each card is an original!

Task
Matching envelopes
Print a set of cards using colored paper or card and then add other colors. This gives the effect of a multicolored print run. You can also put part of the design on the envelopes.

©DIAGRAM

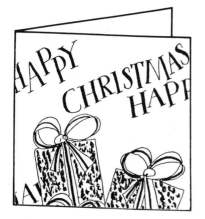

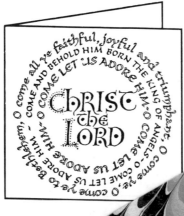

Finishing touches
Cards can be printed in black and have finishing touches made by hand afterwards. This gives the effect of being a handmade card. Use gold and silver pens, and paint.

... or card?
... design is being printed onto ... then use it folded twice (**A**). If ... then only fold once (**B**). This ... you will get one paper card per ... with message printed inside, ... two card greetings cards per sheet (the inside will be blank). Check the final size with your envelope size.

Task
Selling cards
Print a set of cards for your favorite charity, putting their name inside the cards and your name and phone number on the back. Keep two or three for reference and sell the rest.

Task
Extending the idea
Use this principle for something other than cards. Invitations, leaflets and price lists all work well. See if you can find a photocopier which uses colored inks. Use better quality paper if possible.

Copyright
You should not write out a poem or a quotation and then sell your design without checking the copyright. If you use the whole poem or piece and sell the card, then you will probably have to pay a fee. If you're not going to sell the cards, then you may not have to pay for using the words.

Special occasions

This project is as much about organization as it is about calligraphy. A wedding or similar occasion is an ideal opportunity for you to use your calligraphy – as long as you've been practicing! Printing and handwriting names combine to make this a big project, but you don't have to do it all at once. If you feel daunted by the idea of doing invitations, menus, place cards and seating plans, just think of them as centered lists or labels.

The flexibility of Italic makes it ideal for this project, and you can play with a few flourishes if you like. People are often delighted when they see their names beautifully written, and it may be the first time they've seen what design lies within it. One or two ideas are given here, but only use them as starting points. You'll find that new ideas come to you as you go along.

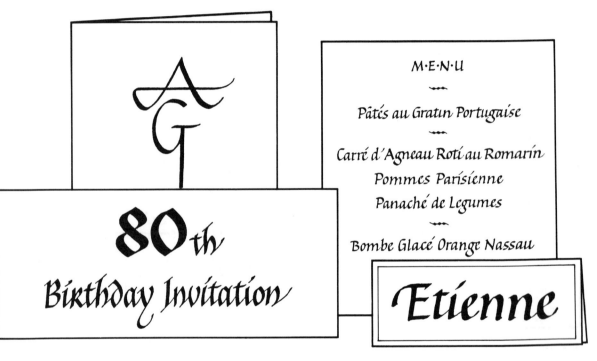

AG
80th
Birthday Invitation

M·E·N·U
Pâtés au Gratin Portugaise
Carré d'Agneau Roti au Romarin
Pommes Parisienne
Panaché de Legumes
Bombe Glacé Orange Nassau

Etienne

©DIAGRAM

Invitations

These are traditionally centered so you've probably already learned most of the skills needed (see pages 44-45). Use a larger nib for the name of the celebrating person or couple and leave extra space around it to help people focus on it. You might like to add a design or use a color which will link up with the occasion itself. Your printer will be able to advise you on weight of card and color effects. When you have completed your design, mount it on card to protect it. An alternative to the single sheet card is to use a paper insert, possibly in a contrasting color. If you work to a size larger than the final printed size, then bear in mind what effect the reduction process during printing will have. Generally speaking, it's a good idea to work slightly larger, but check with the printer. Remember to check the spelling carefully (ask a friend to help) and always check the details with the hosts before going to press. Ask the printer for a sample of the card so that you can try writing on it. Make sure that the pen does not snag and that the ink does not "bleed" into the card too much. Try to obtain a typed guest list to work from, to avoid mistakes. If you use paint, remember to protect the words with fixative after writing.

Menus

Menus are usually done some time after the invitations, and you may like to do them in the same style to give an impression of unity. Make sure you check the spelling with the manager of the venue. A pleasing effect can be obtained by matching color schemes, lettering or design, or adding the same motif throughout.

Placecards

The name of each guest can be written on a small stand up card. You may like to add a motif or illustration, or match the color of the ink with table decorations, flowers or linen.

∞D∞		∞L∞	
Mrs Joyce Dickenson	1	Steve Lamer	3
Mr Norman Dickenson	1	Alison Lamer	3
Irene Dickenson	1	Samuel Lamer	2
Micheal Dickenson	1	Alistair Lucas	2
Stephen Dickenson	1		
Mrs Joan Dickenson	2		
Mrs Mary Dickenson	2		
Mr James Darling	4		
Mrs Harriet Darling	4		
Mr Tom Dawls	2		
Mrs Joanna Dawls	2		
Keith Duman	4		
Sue Duman	4		
∞G∞			
Mrs Harriet Griffen			

Preparation

When the hostess has received all the replies you can start the seating plan. The details may not be finalized until shortly before the event, but you can do some preparations beforehand to save time.

- Rule up card ready for the alphabetical guest list.
- Make place cards for all the guests who were invited and throw away any unwanted ones later.
- Design the overall layout of the plan. Write out the banner heading to draw as much attention as possible. Choose the color of the background card and a picture or photograph for the centre.

Leave details such as actual table positions until the hostess has made her final decisions on the arrangement.

The seating plan

This is done as a series of lists, one for each letter of the alphabet. They are written out on separate sheets of card and then mounted on large sheets of background card. The reason for breaking it up in this way is that if you do go wrong, it only affects a very small part of the overall plan and can easily be redone. Buy some large sheets of background card in a color which goes with the decor and the flowers etc. Rule up lines on the writing card approximately ½in (12mm) apart. Use a hard pencil and keep the lines as faint as possible. Find the longest name and write it out. This will give you the width of the

lists. You will need to add space at either end of the name and also space for the table number. Start 4in (100mm) down from the top of each sheet and allow the same space again for the big initial letter. Leave the same space once more between the bottom of the big letter and the first name on the list.

When you have been given the final list you can trim the cards ¾in (20mm) after the last name in each alphabetical group (don't trim until then!). When all the lists are done, lay them on the floor on top of the background card and play with the arrangement until you find one you like. Use a set square or a T square to

keep them straight. When you have decided on the final layout mark the corners of each list with a pin prick and then stick down one by one. You might like to add a central image to the plan as a focus. Perhaps some initials would be appropriate for a wedding, or dates or a photo for an anniversary.

Task

Seating plan

This project involves ruling up and planning. Do a mock up of the whole plan as if for real. Find out the pitfalls before a real occasion comes up.

Designing posters

Posters are fun to do, but never underestimate how long it takes you to make a successful design; you will make several changes before you achieve a good result. If some handmade posters are required, a few short cuts are worth knowing. If your design is for print you can cut and paste to get it just right. Either way you will want to display good letterforms and use space and color to arrest people's attention. Write out the various pieces of information and play around with them until the positions look right; tape in position and ask others for their comments; make final adjustments and write out one for final approval; then mass-produce them.

Points to consider:

● Use a grid to help you align information vertically as well as horizontally. This can either be a pattern you have drawn yourself, or you can just put a piece of squared or graph paper under your sheet of layout paper so that the lines show through and act as a guide.

● Make plenty of rough thumbnail sketches of various ideas before you start to write out the calligraphy.

● Don't be afraid to edit the information and check the spellings.

● Check that the text gives all the necessary information. What? Where? When? Why? How much? Who? Try showing a rough sketch to a friend – they will have a more objective view than you, and may be able to spot errors and omissions.

● Have more paper available than you need, and be prepared to waste some experimenting with color and pen size.

● If you can't decide which of your sketches has the most potential look at them in a mirror. This enables you to judge which one arrests your attention when you are not distracted by reading.

● Work as large as possible. You can photocopy the design, reducing it for use as handbills. If you need handbills but find that your poster loses too much in the reduction process, then do a simple design at the smaller size.

● Use colors appropriately. Don't ignore the potential of black and white which can be very arresting in a busy environment.

● If you feel the poster needs some illustration, add logos, motifs and drawings. If you don't draw, look in your resource box, trace a picture or use a silhouette. Alternatively, ask an artist to help you. Children's art can work very well.

● Sometimes people will not display a large poster as they look intrusive, so several smaller ones work better. They can be used singly or in multiples.

● Posters generally need to be protected from the weather if used outdoor in public places. This can be done by spraying, covering with transparent film, or putting them into a frame.

Task
Two versions
Design a poster with one of these texts. Use a double pencil and decorate the letters. Find a silhouette or other design motif and complete the piece. Date it and redo the design after a gap of about three months. Date this later version also.

Task
Colors for reference
With your sketch pad make some rough designs using the texts here. Use felt tip pens to suggest colors. Collect a swatch of colored papers from an art shop and store safely for reference.

Task
Three colors
Use one of the texts given here to do a poster design. Make one finished copy from your final draft. Use three colors and time yourself when you make the copy.

Task
Criticizing your work
Using one of the texts shown here, design a poster using 11 × 14in (A3) paper. Take it to a photocopier and enlarge it to double the size of the letters. Criticize the letterforms. Redo the poster at 18 × 24in (A2) size and see whether the lettering gets better or worse.

Texts for poster exercises
These have all been deliberately chosen to cause you a few problems! Don't be put off, you can achieve a good result with a little effort. There are no definite rights and wrongs – only several alternative solutions to each problem.

Beckford Junior School Orchestra Spring Concert
In the School Hall Friday 3rd March at 2pm. Parents and friends welcome. Tickets 50p and 25p for children.
Refreshments will be served afterwards in the canteen.
All proceeds go to the school travel fund.

Downtown College of Further Education
Calligraphy class Monday
 2-4pm
 Tuesday
 7-9.30pm
Enrolling this week in the Main Hall 10am-6pm. Reduced fees for local residents, retired citizens and students.

Stop smoking. It damages your body. Today is no smoking day. Take a big step for humanity and stop smoking. If you smoke 20 cigarettes a day, it costs you £500 a year, so think of all the things you can do with that money. Are you capable of such a big step?

Garage Sale. Saturday 8th October 1pm-dusk
17 Stratford Rd., NW4. Proceeds to Save the Children Fund.

Producing posters

Handmade posters

If you need only one or two posters then making them by hand is the best way. Printing is economical only when quantities are needed. The major advantage of making a number of posters by hand is that they can all be slightly different, with varying colored elements or decoration, and yet still be the same basic design. There are lots of things to do which will add interest to your design:

● Make stencils and cut out motifs or individual letters from card, paper or felt. Stick them on, creating a collage effect.

● Write out your letters in outline and flood in with color, or pattern them.

● Spray, stipple and blot color on your work.

● Add rubbings and other interesting textures. These ideas can complement your basic calligraphic designs and make each poster quite individual. The theater poster on the right is a good example of an effective black-and-white handmade poster.

Printed posters

Having posters printed offers options. Color is expensive to print, but if you use colored paper and black print, you achieve a colorful effect at minimal cost. Long print runs are cost effective and free your energies to concentrate on the design quality.

Preparing for print

Photocopying is the cheapest method of printing for a print run of up to 500 copies. The largest size most photo-copying shops have is 11 × 14in (A3). You can use black and white most effectively and add color by hand afterward. Splattering, streaking, using colored washes and sticking on colored paper are all possible ways of doing this. A black and white poster stuck on a colored background can be most effective. The real bonus of a print run is that you can reduce your lettering, motifs and logos when you are pasting up.

You need not conform to the tradition of making posters portrait shape (upright). Good lettering on a simple design will convey information clearly. It is therefore a good idea to concentrate on the quality of your lettering rather than on an over elaborate design. Refer to pages 48 and 49 for instructions on paste-ups.

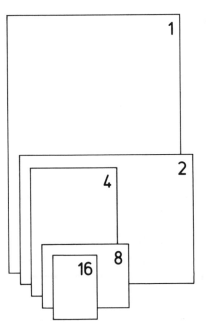

Exhibition posters

These two posters solve the problem of presenting the reader with a list. In each case the answer was to use capitals closely stacked and plenty of space. A list which has a straight left hand margin (left justified) is easier to construct than one which is right justified. Centering and right justifying both need to be pasted up, whereas left justifying only needs the length of the longest line to be found. That distance is then measured in from the right-hand side, and the resulting point is where the lettering can start from.

Sizes and proportion

Work twice as large as your final design. Reducing the size minimizes unevenness in your writing. Also, you can print twice or four times as many small posters for the same price as large posters. Use the same design as the posters but reduce the size for handbills (1 large poster=4 small posters=16 leaflets or handbills, *left*). Bear in mind that many people are unwilling to display large posters, so have plenty of smaller versions to hand.

Method of working

If you have to make more than one copy of a poster your method of working should be designed to minimize time wasting. The following points are useful to remember:

- Always do plenty of preliminary roughs first, then write out your text using a variety of pens in different styles and sizes of letterforms. Make a final paste-up when you are satisfied with your design.
- When you have completed one good paste-up lay it over several sheets of the paper you are using for your poster, and prick through the positions of the writing lines and beginnings and endings of large letters. This saves a lot of time and avoids inaccuracies arising when you want all copies to match each other.

- Additional dots for your eyes only can mark the positions of letters within a word, so you avoid ending the line with too little or too much space.
- It will be upsetting to go wrong at the end of a piece of work so, rather than completing each poster in turn, the rule is to do the most difficult part of the design first (usually the eye catching lettering) on all posters you plan to do. Then you do the next most difficult part in the same way. This method means that you can abandon a bad poster at a relatively early stage. It also helps prevent getting nibs and colors mixed up.
- After completing each area of lettering, hang it up or lay it down on a flat surface to dry. If you think your ink might run, then perhaps you're using too much.

Task
Working with a grid
Choose one of the poster texts from the previous page and design a poster. Use a grid, either draw one of your own, or add vertical lines to the one on page 78.

Task
Resources
Look for logos in advertisements and refer to them when making posters. Silhouettes and pictures of buildings, plants, animals and people can all be used to complement your lettering. Keep resources like these in a box or a file. They can be traced off, photocopied, reduced or enlarged, and stuck on, either singly or in groups.

ART GALLERY

Summer
EXHIBITION

PAINTINGS
CONSTRUCTIONS
COLLAGES
GOUACHES
DRAWINGS
SCULPTURE

JULY 23 – SEPTEMBER 29

7

European
Carpets
from
BRITAIN
DENMARK
SWEDEN
NORWAY
GERMANY
POLAND
and many other countries

ON THE 4TH . FLOOR
SEPTEMBER 29. – OCTOBER 25.

©DIAGRAM

Poetry and prose

Writing out any text requires a certain amount of planning – a fact which may not be obvious when looking at the finished piece! Good writing needs rhythm, sharpness and a sense of freedom. You can achieve this if you plan everything BEFORE you begin your final version.

Planning a layout

1 First, consider the meaning of the poem, quotation or piece of prose. Check spelling, author and punctuation. At this stage you only have to choose between Italic and Foundational hands. Later on you may acquire more skills and have other hands to choose from. Consider what sort of size or shape you might be required to adhere to.
2 Make some thumbnail sketches using handwriting. Always draw a shape around your ideas.
3 Write out your text using different sized nibs and capitals for some sections. Use a larger nib but SAME SIZE LETTERS for pieces you want to emphasize; this is an alternative to using capitals. Photocopy at this stage if you can.
4 Do a paste-up. Adjust anything which needs to be changed and consider weight and balance carefully. Is there harmony in your color scheme? Does it all hang together well? Above all, can it be easily read?
5 When you're satisfied with your paste-up, use a pin to prick through where lines are to be drawn. Rule up on your best paper and write it out. Refer to your final paste-up whenever you wish. When your work is dry, begin finding the edges of your piece by moving four long strips of card around the sides. Leave as much space as you can around the piece, in order to set off the words.

Comments on thumbnail sketches
A A large initial overpowers three lines.
B Has possibilities.
C Written this way round it becomes too staccato. It's a good idea, but does not work for this particular quotation.
D Simple – but a long shape. Author?
E The capitals certainly draw the reader's attention. Worth writing out a second time; balance the weight of lines 1 & 4 with 2 & 3.
F Similar to B; must watch how lines sit under one another.

MOST PEOPLE

no 3 w.m. Pen.

would succeed in small things

if they were not troubled by

GREAT AMBITIONS

LONGFELLOW

most people

no 3½ w.m. Pen

would succeed in small things

if they were not troubled by

great ambitions

LONGFELLOW

Toward the final version
From the various thumbnail sketches two ideas have been developed further. In the first version the capitals do not relate to the rest of the text. It is as if they are shouting at the reader. In the second version the lines need rearranging to form a harmonious shape. Nevertheless this one would seem to be the most effective. Often simple ideas are best.

Task
Hot and cold
Take a short quotation and, using paint, write out a "cold" version and a "hot" version, just by changing colors. Cold colors include gray, blue and green. Hot colors are yellow, orange, pink and red. Does one color scheme suit it better than another? Consider some other quotations in the same way.

Task
Experiment
It is a good idea to paste up using photocopies if you can and practice experimenting. If you are too anxious to progress, you won't experiment enough. This can force you to settle for something which looks adequate, but may not be the best design you are capable of. Take a well known proverb or saying and see how many possibilities there are.

Review

Throughout this book there have been constant references to practice. The tasks will have taught you a variety of skills and have structured your experience. It is only by using tools well, employing useful techniques, understanding basic letterforms and attempting projects that you will gain the experience you need to enjoy calligraphy.

Each chapter sets you tasks to ensure that you learn gradually the basic skills every newcomer to calligraphy needs to know. There will always be pieces of work you are not satisfied with, so repeat and improve on tasks and projects you enjoyed doing.

However limited you may feel your calligraphy skills are, be generous to yourself and persevere with it as long as it gives you pleasure. It is unlikely that you will be completely satisfied with your work and it is important to complete projects and not merely doodle with your pen.

For a long time it had seemed to me that life was about to begin-real life. But there was always some obstacle in the way. Something to be got through first, some unfinished business; time still to be served, a debt to be paid. Then life would begin. At last it dawned on me that these obstacles were my life.

B. HOWLAND · Calligraphy by David Mekelburg

Obstacles
This freely-written Italic hand conveys a rather profound and very touching statement.

Task
Framing
Calligraphy enables us to read poetry easily. A handwritten poem is worth displaying. Buy a simple clip frame and put one of your best pieces of work in it. Using a clip frame allows you to change the poem for another.

Task
Quotation
Using a piece of thin card folded into a concertina shape, write out a favorite quotation for a friend. This makes it more special than a greetings card, but not a formal piece of calligraphy. Use color, and perhaps make an envelope to give the work in.

Task
One for yourself!
Go through some poems and make some thumbnail sketches of ones that are important to you. Allow yourself as much time as possible. Finally, write out one just for the sheer delight of writing.

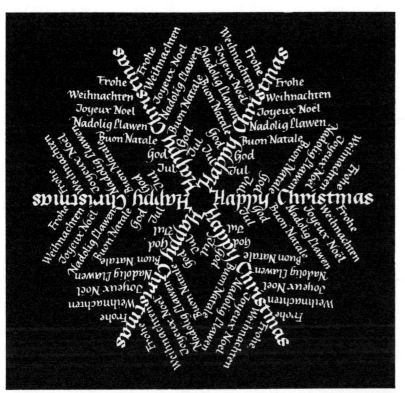

Christmas card

This multi-lingual Christmas card is white on a dark ground. Dark blue, dark green, brown maroon, etc, are all ideal backgrounds for crisp white letters.

Task
Pleasure

Even if time for practice is limited, go to exhibitions, collect good samples of calligraphy and lettering, and enjoy the pleasure that good lettering can give.

Quotation

Lines from the poet John Clare by Wendy Westover using brush and pen, white and brown paint on Kraft paper.

> JOHN CLARE **AND WHAT IS LIFE? –**
> *A mist retreating from the morning sun,*
> **AN HOUR-GLASS**
> *A busy, bustling, still repeated dream.*
> **ON THE RUN,**

©DIAGRAM

Guidelines

These guidelines can be simply traced off or photocopied. If you enlarge or reduce them you get a set of lines to work with nibs of various sizes.

Foundational

Aaph

Foundational

Aaph

Formal Italic

Formal Italic

Basic templates

Calligraphic terms

Ascenders
Pen strokes which project above the writing line. For example, b, d, h, l.

Carolingian
From the time of Charlemagne – a period of great calligraphic value.

Colophon
An endpiece to a piece of work, often tiny, referring to the author, date etc.

Counter
The inside shape of a letter.

Cursive
A "running" hand in which the letters are joined up, for example, Italic handwriting.

Descenders
Strokes which go below the writing line. For example, g, y, p, q.

Flourishes
Ribbon-like pen strokes used with Italic lettering.

Foundational hand
Edward Johnston's teaching script, developed from traditional sources.

Gloss
A translation or explanation. Often added to a manuscript much later than the original script, either in the interlinear spaces or in the margins.

Illumination
The process of decorating manuscripts. It literally means to "light up" a manuscript by the use of raised gold (gilding).

Initial
The first letter of a piece of work or of a verse, often colored and decorated or illuminated in manuscripts.

Italic
A generic term meaning a writing form developed in Italy, characterized by its slant and cursiveness.

Justification
A typographic phrase meaning to align rows of letters so that their edges form straight lines.

Ligature
The small joining line between two letters in a word.

Lower case
"Little" letters, often having ascenders or descenders, as opposed to capital (or majuscule) letters.

Majuscules
Capital letters. See – upper case.

Minuscules
Calligraphic term for "little" letters. See – lower case.

Monoline
Letters without thick and thin strokes. For example, skeleton letters and any letters written with a ball-point or "roller ball" pen.

Parchment
Stripped sheepskin, used instead of paper for pen lettering.

Pen angle
The angle between the writing line and the thinnest stroke of a broad edged pen. For example, Foundational hand is written with a writing angle of 30°, Italic with an angle of 45°.

Serif
A small finishing stroke for letter strokes.

Stress
The angle of the thickest stroke in a letterform.

Swashes
Extended strokes on letters which convey elegance.

Thumbnail sketches
A first draft for a text. A pencil or ball-point pen may be used for this set of sketches to explore opportunities.

Upper case
Typographic term for capital letters, also called majuscules. Upper and lower case refer to the flat trays (cases) which printers used to store metal pieces of type in.

Vellum
Calf skin or goat skin treated for pen lettering. Expensive and very beautiful to write on.

Weight
The "heaviness" or "boldness" of letters. Determined by the height of the letter in relation to the width of the nib used.

X-height
The height of lower case letters excluding the ascenders or descenders.